NORTH EAST CANALS

Aire & Calder, Calder & Hebble,
Huddersfield Broad Canal,
Dearne & Dove, and Barnsley

THROUGH TIME

Ray Shill

AMBERLEY PUBLISHING

First published 2014

Amberley Publishing
The Hill, Stroud, Gloucestershire, GL5 4EP
www.amberley-books.com

Copyright © Ray Shill, 2014

The right of Ray Shill to be identified as the Author
of this work has been asserted in accordance with the
Copyrights, Designs and Patents Act 1988.

ISBN 978 1 4456 3321 3 (print)
ISBN 978 1 4456 3335 0 (ebook)

British Library Cataloguing in Publication Data.
A catalogue record for this book is available from the
British Library.

Typesetting by Amberley Publishing.
Printed in Great Britain.

Contents

Introduction

A central theme to this book is river navigations. While canals have formed a major part of this series to date, the routes east from Leeds, Huddersfield and Sowerby Bridge were essentially river navigations that had been improved and modified to include canal sections for the benefit of the trade along them. The rivers in this case comprised the Aire, Calder, Humber and Ouse. Equally, the routes northwards from the East Midlands also relied on the Trent, whose widening channel provided the means for craft to reach the Humber and the North Sea.

Trade was at the heart of this traffic and the need to exchange minerals and merchandise with coastal or seagoing vessels at the Port of Hull. Some of the craft that navigated the rivers, such as sloops and keels, also had the capacity to trade along the coastal waters in the same fashion that has previously been noted in other books in this series.

Common vessels in these parts were known as keels, and sometimes more specifically as 'Yorkshire Keels'. In addition to navigating the rivers, they would follow the coastal waters through to Lincolnshire and further south.

Merchandise and minerals were conveyed in varying amounts. Wool was an important cargo, as was coal from the West Yorkshire mines, particularly during the nineteenth and twentieth centuries. Coal was not only conveyed for local consumption; an increasing amount went to the port of Goole, from where it was distributed along the coast or for export. Yorkshire coal was often prized for gas making, and coastal craft collected gas coals for carbonisation at the large gasworks in London. During the twentieth century, coal was also carried to the various riverside power stations, which initially had been built to supply power for street tramways but gradually were enlarged to meet domestic and industrial needs.

Chapter 1
Navigation from Leeds to the Sea

River Aire, Aire & Calder Navigation and the Selby Canal

Waterway links to serve the Yorkshire wool industry first began with the navigation of the Aire from the Ouse to Leeds. The Aire had been navigable for craft as far as Knottingley Mill weir, but, following the 1699 Act, the navigation was extended along the Aire to Leeds, and along the Calder from Castleford to Wakefield. Bypass channels and lock cuts enabled small craft to reach Leeds Bridge in November 1700. John Hadley was the contractor for making the river navigable to Leeds. Making the Calder navigable to Wakefield proceeded more slowly, but boats were able to reach Wakefield during 1702.

Navigating the Aire from the Ouse involved a winding course near Haddesley, where a lock was provided. This route was augmented by the making of Selby Canal, in 1788, which provided an improved passage for craft to the River Ouse, as well as shortening the distance for craft travelling to York and Ripon and other destinations on the Wharfe and Fosse.

At first, navigating the Aire and the Calder was essentially restricted to the river, with locks providing the means to pass the weirs. As trade improved, more canal sections were provided. Both William Jessop and John Smeaton suggested alterations. Early improvements included the Brotherton Cut, near Ferrybridge, during the 1770s (to John Smeaton's survey), and a section of canal near Leeds known as the Cryer Cut (to a plan of William Jessop), which was constructed on land belonging to Lord Hertford and for which an annual rent was paid by the Navigation. The locks were also enlarged to enable the passage of larger craft.

The Aire and the Calder river navigations were, like many others, subject to periods of flood and periods of low water. Such was the concern to maintain trade that the navigation company engaged various engineers from time to time to suggest improvements to their navigation. John Smeaton made some basic improvements, but the more important alterations were made during the nineteenth century.

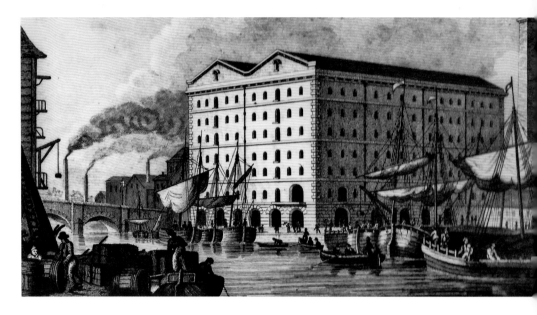

Canal Warehouse, Leeds, Aire & Calder Canal
The Aire & Calder Navigation's first warehouse and wharf, of 1700, was placed on the north bank of the River Aire, east of Leeds Bridge. Between 1826 and 1827, a large, new warehouse was erected on this wharf as part of the improvements to the navigation. (*RCHS Collection, 40008*)

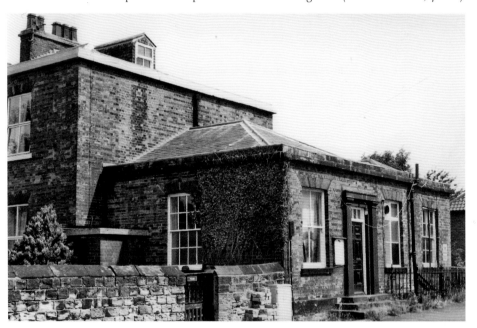

Canal Offices, Castleford, Aire & Calder Canal
Castleford was the meeting point of the navigations from Leeds and Wakefield. The company offices (known as the Packet Office) were strategically placed beside the flood lock entrances and the River Aire. Trade on the river passed between Leeds/Wakefield and Selby, where vessels carried merchandise to London contract vessels that sailed from Selby. (*Ray Shill, 603004*)

Castleford Flood Locks, Aire & Calder Navigation

Castleford Cut was at first a short canal that bypassed the weir. This waterway was widened from time to time and extended to a new lock at Bullholme. The original lock was retained, although most traffic continued onto Bullholme. There were boat-building docks and yards placed here. (*Ray Shill, 600314, & RCHS Hugh Compton Collection, 64006*)

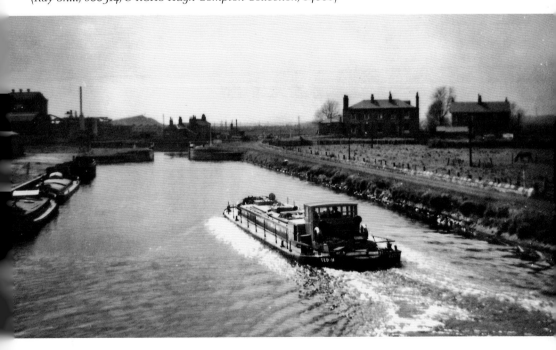

Castleford Flour Mill, Aire & Calder Navigation
The flour mill at Castleford was built beside the weir, and craft were able to moor up above the weir alongside the mill. (*Ray Shill, 612125*)

Knottingley Weir Approach, Aire & Calder Navigation
The original navigation was required to pass Knottingley Weir, which had been the limit of navigation prior to this waterway being made navigable to Leeds. The original lock was replaced by a lock cut on the far right, known as the Brotherton Cut, which was made during the 1770s, to a plan surveyed by John Smeaton. (*Ray Shill, 612285*)

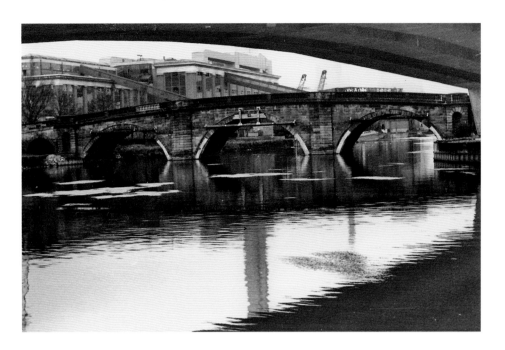

Ferrybridge, Aire & Calder Canal
A survivor from the period of the original navigation is the stone bridge that spanned the river at Ferrybridge. It still spans the modern navigation. There are two plaques on this bridge: architect John Gagg of York, 1797, and contractor Bernard Hartley of Pontefract, 1804. (*K. Gardiner Collection, 66021*)

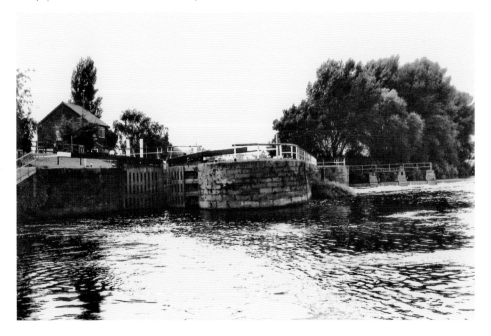

Beale Lock, Aire & Calder Navigation
Beale Lock was placed on the original navigation from the Ouse to Leeds and Wakefield. (*Ray Shill, 601065*)

West Haddesley, Flood Lock, Selby Canal
With the completion of the Selby Canal in 1778, a level waterway was made from West Haddesley through to Selby and its river lock. (*Ray Shill, 608004*)

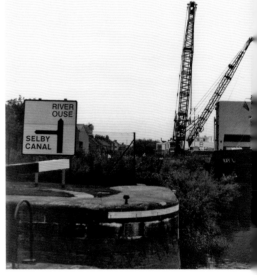

Selby Lock, Selby Canal, 2000
The Selby Canal was constructed between 1775 and 1779. William Jessop was the engineer, John Gott was resident engineer, and James and John Pinkerton were the contractors building the canal. At Selby, the canal entered the River Ouse near the river wharf. (*Ray Shill, 608812 & 608925*)

Chapter 2
Navigation along the River Calder

Aire & Calder Navigation (Wakefield Branch & Dewsbury Cut), Calder Navigation and the Calder & Hebble Navigation

The navigation of the Calder from Castleford to Wakefield was part of the Aire & Calder Navigation, and was completed for the undertakers of the 'Wakefield Navigation' by the making of four lock cuts. It provided trade access to the woollen mills at Wakefield. At first, the navigation was the bending river, with locks and lock channels providing the means to bypass mill weirs. The final canal channel was at Wakefield, where a lock was provided near Fall Ings, on the north bank, for craft to rise up to the channel to the terminus basin at Wakefield, which was near the long weir on the Calder.

Fall Ings, south bank, was the point of access for the original Calder Navigation. The cut and two locks were provided for craft to pass the weir, and access the river upstream. This navigation, in its original form, was engineered by John Smeaton, who had provided for locks and short lock cuts at mill weirs, or fords, as far as the junction with the Hebble Brook, near Halifax. Smeaton also directed the gradual construction work upstream from Wakefield, until he was replaced by James Brindley for the parts around Elland and Salterhebble, which included the original staircase locks at Salterhebble.

It was a route that followed the river as close as possible when it passed through the mill towns en route. The approach to Dewbury included a cut at Horbury Bridge, and two cuts south and west of this town. The navigation reached Dewsbury during 1762, Brighouse in 1764 and Salterhebble the next year.

This was followed by the branch canal section towards the Halifax turnpike at Salterhebble, and the main canal to Sowerby Bridge. The navigation followed the Calder Valley to terminate at a wharf and warehouse in the town of Sowerby Bridge. Serious floods destroyed the works near Salterhebble, but traffic was restored during 1769. In this year the navigation became the property of the Calder & Hebble Navigation.

Smeaton returned to make alterations at Salterhebble and elsewhere. Further improvements were made by William Jessop, which included the Mirfield Cut, the linking of the two cuts at Battye Ford, and the extension of the Brighouse Cut. Thomas Bradley continued the improvements linking up Brighouse with Elland and Salterhebble, making the Thornhill Lees Cut and a new link with the river at Fall Ings. He was later associated with the building of the Halifax branch, opened in 1828.

Wakefield Offices, Aire & Calder Navigation
Above are the elegant stone offices alongside the old wharf at Wakefield. Adjacent to them are warehouse buildings (*below*). (*Ray Shill, 610003 & 610004*)

Wakefield, Aire & Calder Navigation
The cut to the Aire & Calder Wharf entered the Calder opposite Fall Ings. (*RCHS Collection, 40054*)

Lake Lock Depot, Aire & Calder Navigation
Lake Lock was on a section of the Calder east of Wakefield. It was here that the engineering and maintenance department was located. Lake Lock comprised a short cut around the weir, but there was also a private canal that joined the cut built for Lee and Watson, which was made east to the river at Bottom Boat. (*RCHS Transparency Collection, 53061*)

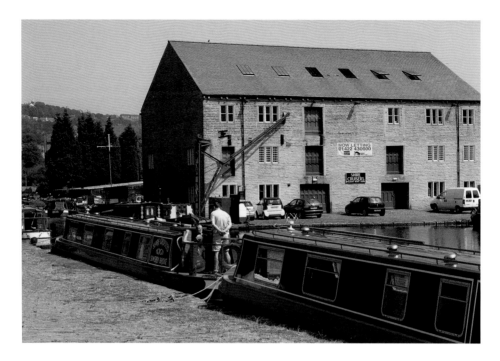

Sowerby Bridge, Calder & Hebble Navigation and Rochdale Canal

Sowerby Bridge was the meeting point of the Rochdale Canal and the Calder & Hebble Navigation. It was, at first, the terminus of the Calder & Hebble Navigation. The warehouse building is thought to have been erected in 1778, and was one of a group of buildings around the terminus basin. With the building of the Rochdale (opened in 1804), Sowerby Bridge became an interchange point between the Yorkshire keels and the flats (among other craft) that navigated the Rochdale. New warehouses were constructed, such as the Salt Warehouse, and most came to deal with the transfer trade. (*Ray Shill, 656008 & 656007*)

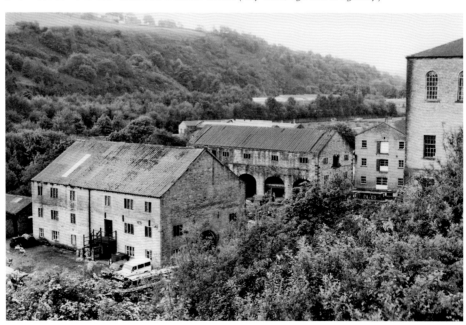

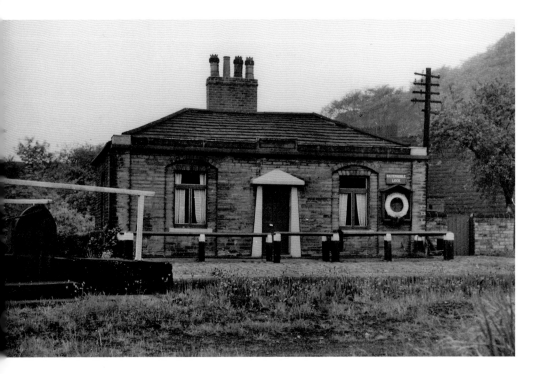

Salterhebble Top Lock Cottage and Locks, Calder & Hebble Navigation

Salterhebble locks were built to the design of James Brindley, and the original arrangement comprised a staircase pair of locks at the top, with another lock that allowed craft to enter the River Calder beside Hebble Brook. Smeaton rebuilt the top two locks, moving the second further west as part of a water conservation exercise. (*RCHS Hugh Compton Collection, 64334, & RCHS Ray Cook Collection, 60007*)

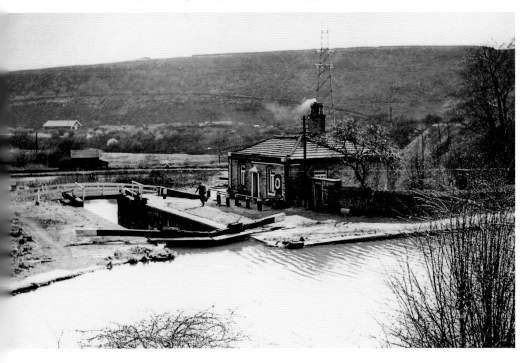

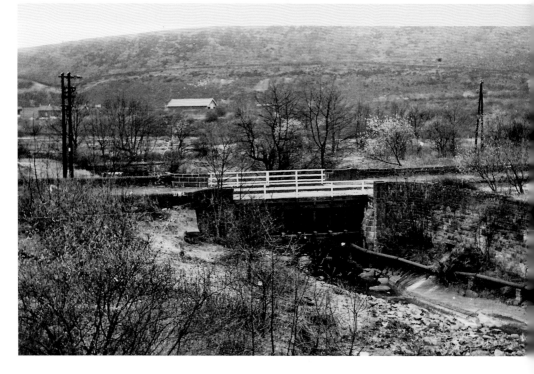

Salterhebble Aqueduct, Hebble Brook, Calder & Hebble Navigation
A later improvement was the diversion of the navigation through to Elsecar, on a parallel course to the river, which involved crossing the Hebble Brook, a third Salterhebble Lock and locks at Long Lees and Woodside. (*RCHS Ray Cook Collection, 60008*)

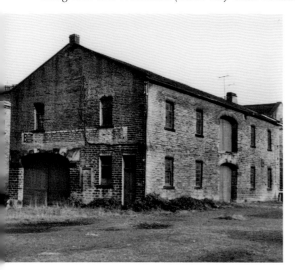

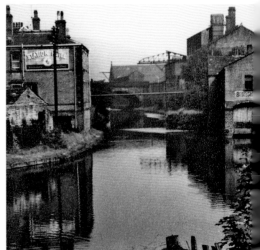

Elland Warehouse, Calder & Hebble Navigation
The warehouse and covered dock at Elland covered the lock chamber, which once formed part of the original cut that bypassed the weir. As part of the ongoing improvements, the canal section was extended from Elland to Park Nook (River Lock) prior to 1792. (*RCHS Collection, 40059, & RCHS K. Gardiner Collection, 66129*)

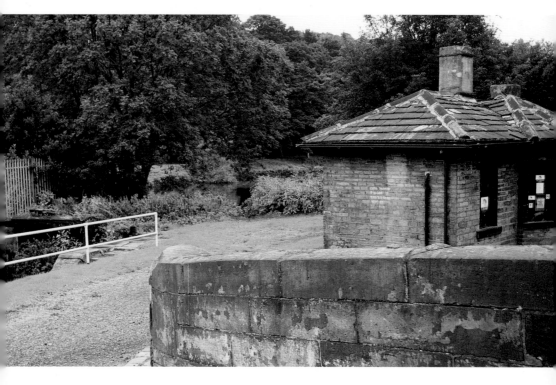

Brookfoot Old Lock, Calder & Hebble Navigation
Engineer Thomas Bradley was responsible for the extension of the canal via Brookfoot and onto Park Nook. A new canal was built (with three new locks at Brookfoot, Cromwell and Park Nook, and a river lock at Brookfoot was provided so that craft could reach the mills at Tag Cut. (*Ray Shill, 660006*)

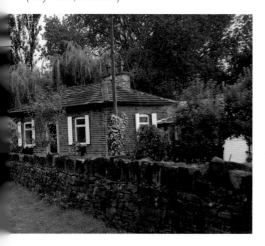

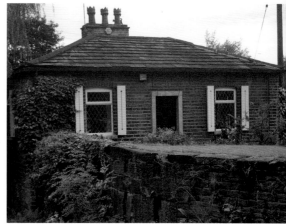

Ganny Lock House, Calder & Hebble Navigation
The alignment of the lock house at Ganny Lock is consistent with a flood lock link to the Calder, following Jessop's extension of Brighouse Cut in 1780. Boats then crossed the Calder to the Lillands lock and cut, and then followed the Calder to reach Tag Cut. With the extension of the canal by Thomas Bradley, Ganny Lock (canal) was made, as was the cut north to Brookfoot. (*Ray Shill, 656542 & 656543*)

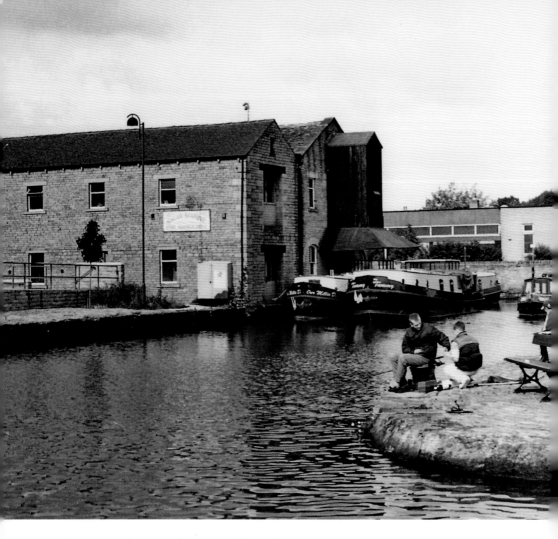

Brighouse Warehouse, Calder & Hebble Navigation
The Calder & Hebble had numerous warehouses, served by flyboats, for the merchandise trade that passed betwee the East Coast ports of Selby and Goole and onto the Huddersfield and Rochdale Canals. (*Ray Shill, 656711*)

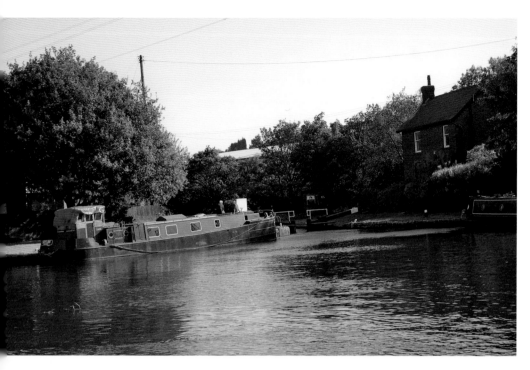

Brighouse Bottom Lock and Lower Basin, Calder & Hebble Navigation, 2006 and 1971
The two locks at Brighouse raised the canal to the level that passed two mill weirs and at first the canal channel joined the Calder above the top weir. Later it was extended to Ganny. This basin once had coal staithes that were linked by tramway, and later railways to mines at Raistrick and eventually Brierley. (*Ray Shill, 656805 & RCHS Collection, 40048*)

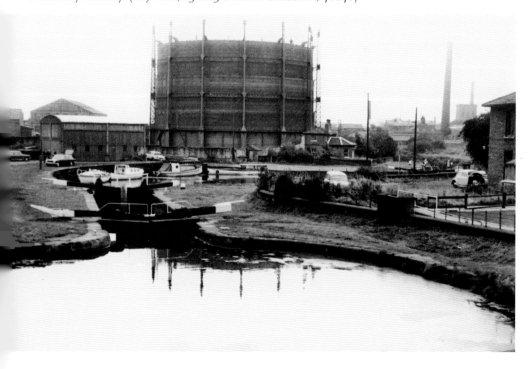

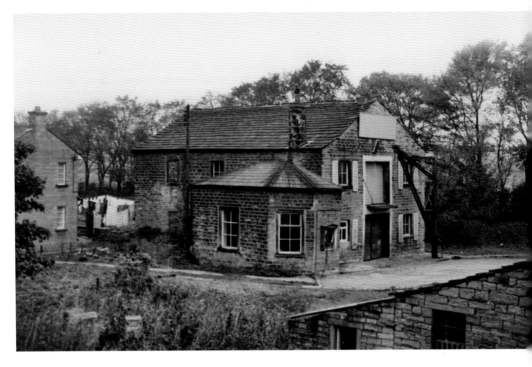

Coopers Bridge Warehouse and Coopers Bridge Lock, Calder & Hebble Navigation
The Coopers Bridge cut bypassed the weir, and later the junction, with the Huddersfield Broad Canal, and is one of the least altered canal cuts. The warehouse was opened in June 1814 for trading vessels travelling between Hull, Manchester, Liverpool, Selby and Wakefield. (*Above: RCHS Collection, 40045. Below: 657252*)

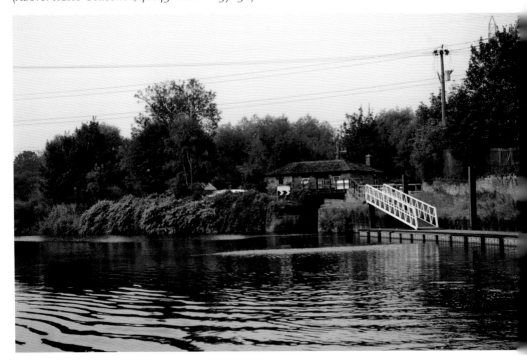

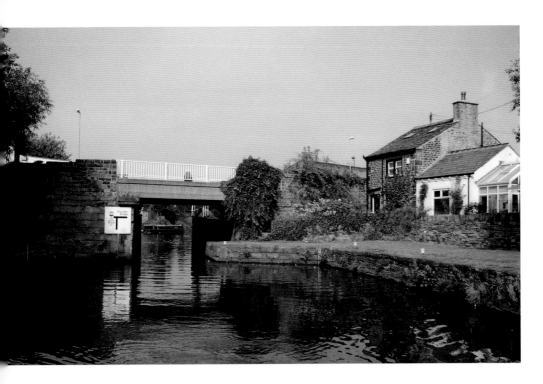

Ledgard Bridge Flood Lock, Calder & Hebble Navigation
With the original navigation, a short canal and lock were provided to bypass the weir at Ledgard Bridge. That lock cut included a pair of flood gates above the weir (*above*). Later, a second pair of gates were added, creating a flood lock there. (*Ray Shill, 757456 & 757458*)

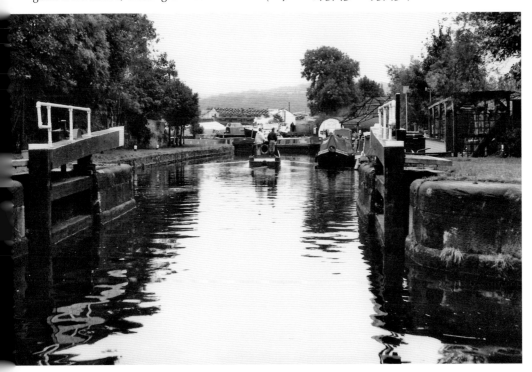

Mirfield Boat Dock Calder & Hebble Navigation, 2006
This boat dock dates back to mid-1779, when William Jessop and John Pinkerton established a dry dock at the site of the original lock cut that bypassed the weir at Ledgard Bridge. Jessop put forward the plan to extend the cut from here to Shepley Bridge, and John Pinkerton, the contractor, made the new cut. (*Ray Shill, 657467*)

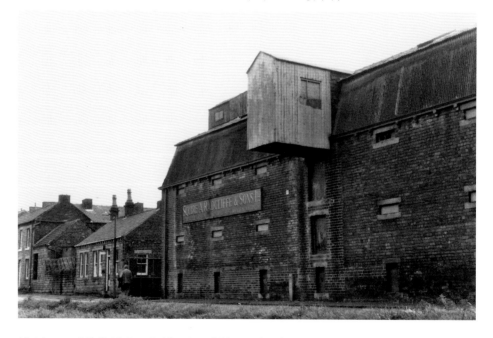

Malthouse, Mirfield Cut, Calder & Hebble Navigation
Industrial features alongside the Mirfield Cut included the now demolished malthouse there. (*Ray Shill, 657480*)

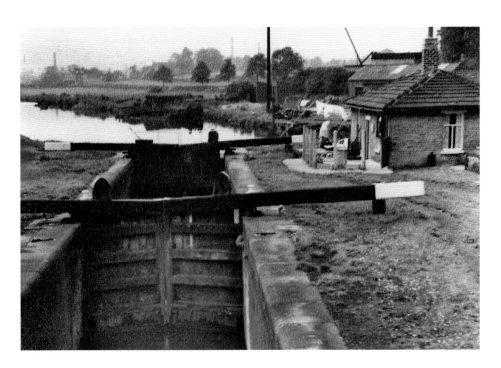

Shepley Bridge Lock, Calder & Hebble Navigation
Shepley Bridge was at the end of the extended cut from Ledgard Bridge, constructed by John Pinkerton during the 1770s. A dry dock, like that at Ledgard Bridge, was built on the opposite side of the lock house and provided a base for boat building. (*Above: RCHS K. Gardiner Collection, 66135. Below: Ray Shill, 657575*)

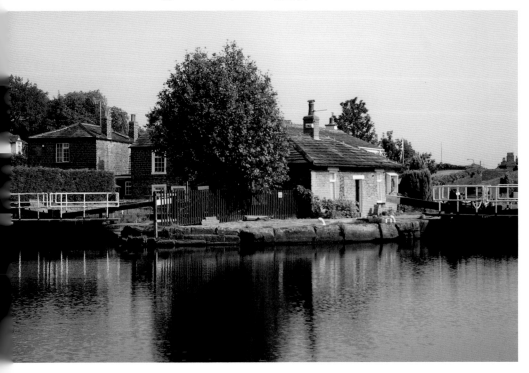

Greenwood Flood Gates, Calder & Hebble Navigation
It was the practice on the Calder & Hebble to fit a pair of flood gates to protect the upstream entrance to the lock cuts. As trade increased, many were converted to flood locks, with the provision of an additional pair of gates. (*Ray Shill, 657600*)

Dewsbury Cut, Calder & Hebble Navigation
Smeaton's original route included the Dewsbury Cut, which took the navigation around the mill weir towards Dewsbury. The lock (at the Dewsbury end) became disused with the making of the new cut through Thornhill Lees, while the remainder was retained to access wharves. (*Ray Shill, 660381*)

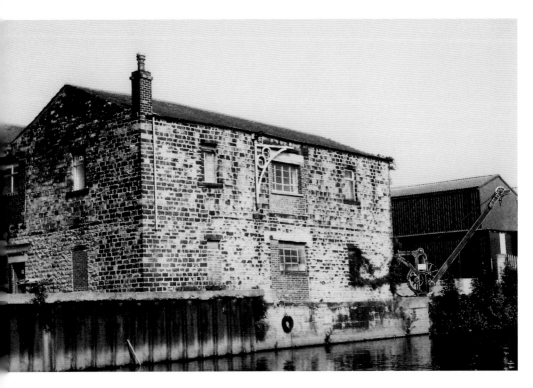

Calder Warehouse & Wharf, Dewsbury, Calder & Hebble Navigation
Calder Wharf was built alongside the River Calder and opposite the entrance to the Thornhill Lees cut. Another wharf, Ravens Wharf, was placed alongside the Calder nearer Dewsbury. (*Ray Shill, 657881 & 657883*)

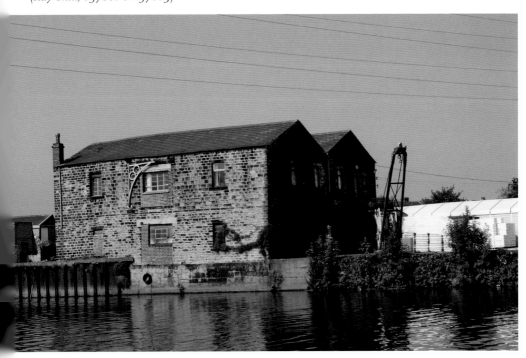

Thornhill Flood Lock, Calder & Hebble Navigation

Thomas Brassey was appointed engineer to the Calder & Hebble in 1792. Between 1793 and 1798, he made an important cut through the Thornhill Lees, which comprised a flood lock (*above*) and a pair of locks (Double Locks) that joined up with the canal, which then extened from the figure of three locks to Dewsbury and enabled craft to avoid the river section through Dewsbury and the Dewsbury and Old Dewsbury cuts. (*Ray Shill, 657901 & 657992*)

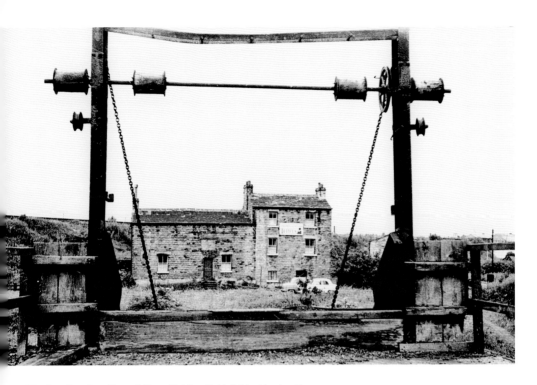

Navigation Inn Broad Cut, Calder & Hebble Navigation
This inn is set back from the present Broad Cut, but was closer to the original cut. (*RCHS K. Gardiner Collection*)

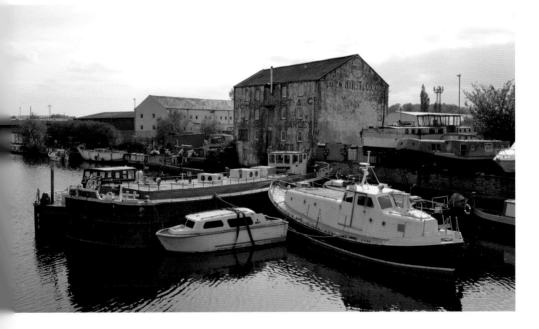

Thornes Road Wharf, Wakefield , Calder & Hebble Navigation
Thornes Wharf and boatyard were placed opposite the company warehouses and close to the weir. (*Ray Shill, 658861*)

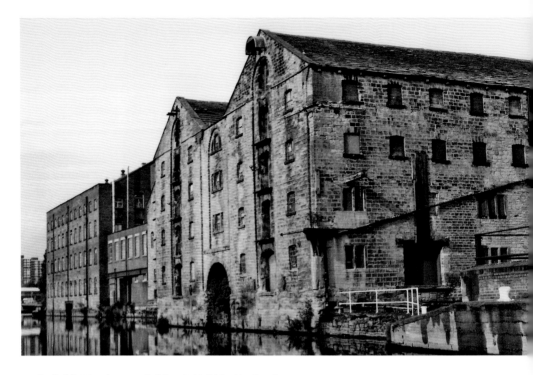

Wakefield Warehouse, Calder & Hebble Navigation

These warehouses were built for the Calder & Hebble Navigation during 1790. They were built as two separate buildings but joined together in 1816. Built of stone, they comprise four storeys and an attic. They are Grade II listed. North of these was another warehouse (built around 1800) that became a corn mill in 1850 and a hosiery mill from 1876. That building is also Grade II listed. (*Ray Shill, 658885 & 658888*)

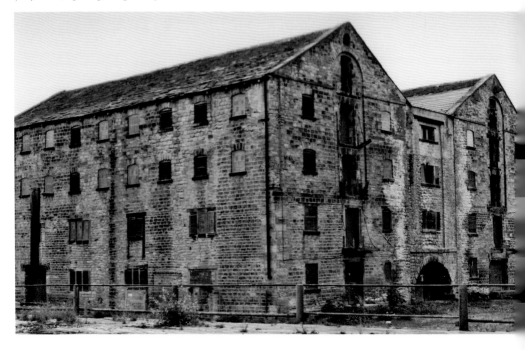

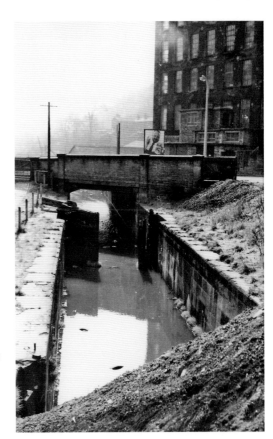

Halifax Canal, Calder & Hebble Navigation
One of Thomas Bradley's last acts as engineer was the making of the Halifax Branch, which ascended through locks to the terminus basin at Halifax. (*RCHS Ray Cook Collection, 60005 & 60003*)

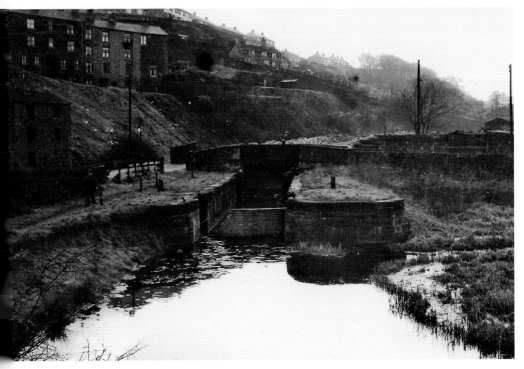

Chapter 3

Sir John Ramsden's Canal and the Huddersfield Narrow Canal

Sir John Ramsden's Canal was built to link Huddersfield with the Calder & Hebble Navigation near Coopers Bridge. It terminated near Shore Mill and Mill Stream at Huddersfield.

The Ramsden family owned much of the town, including Shore Corn Mill, and the construction of the canal to the canal wharves at Apsley maintained, and perhaps improved, the supply of water to this mill. Water for turning the wheels and driving the corn-grinding stones at the mill came from the River Colne, via a stream or goit, that channelled water from above the dam to the mill. According to the Act of 1774, with the completion of the canal, the water channel for both mill and canal supply was further north, close to and below the dam at Kings Mill. This supply was protected against floods by flood gates. Water that passed the mill wheels was delivered into the tail goit at a lower level, which was carried under an aqueduct on Sir John's Ramsden's Canal and back to the River Colne.

The building of the Huddersfield Narrow, from Apsley Basin through to Ashton under Lyme, created a navigable link that united waterways in the North West with the North East. It was the second such link to open. The junction at Huddersfield was made below the First Lock, with craft entering the former feeder from the Colne.

The principal length of the Huddersfield Canal from Ashton to Lock 3 was discussed in *Northern Canals Through Time*. This volume will deal with the remaining section. Lock 3 was placed west of Chapel Hill (or Engine) Bridge and it was here, also, that the Narrow Canal had a wharf and warehouse. After Lock 3, the canal descended through the fields to join John Ramsden's Canal. This section passed to the Calder & Hebble Navigation from 1 January 1945, following the official abandonment of the Huddersfield Narrow Canal to commercial traffic by the London, Midland & Scottish Railway. Water supply to the mills was retained, and this water also supplied John Ramsden's Canal.

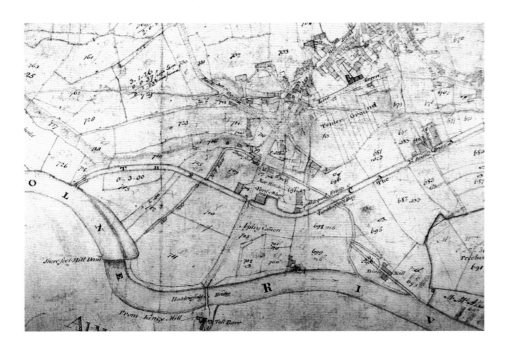

Sir John Ramsden's Canal at Apsley, December 1778
This map shows several features, including Shorefoot Mill, New Warehouse Wharf and Yard, Frizing Mill, warehouses and the aqueduct bridge at Tumbling Bay. (*Huddersfield Local Studies Department, 749501*)

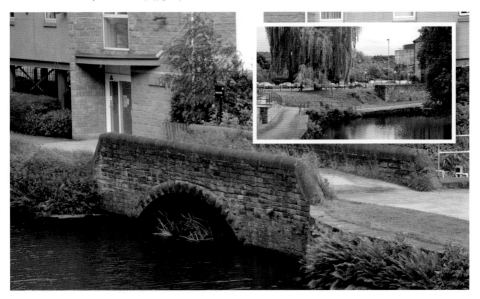

Apsley Goit, Huddersfield Broad Canal
The Broad Canal feeder from the Colne crossed the millstream (Apsley Goit) to Apsley flour mill, which was later adapted as another feeder for the Broad Canal, as well as providing water for the mill. With the making of the Narrow Canal, the Colne Feeder entered below the bottom lock, and the channel was improved for navigation through to the Apsley Wharves. (*Ray Shill, 749504*)

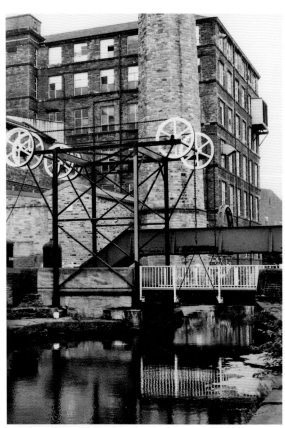

Locomotive Bridge Huddersfield Broad Canal
The Lift Bridge (Locomotive Bridge) was provided in 1865 to replace an earlier swing bridge at this point. (*Ray Shill, 749541 & 749544*)

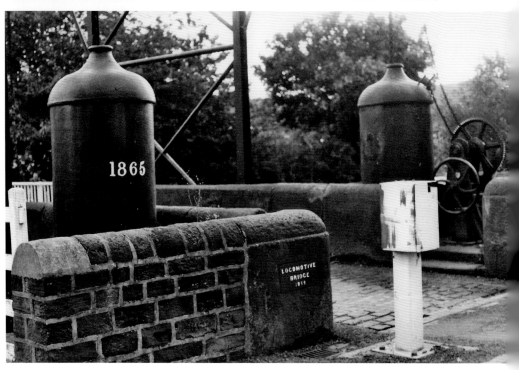

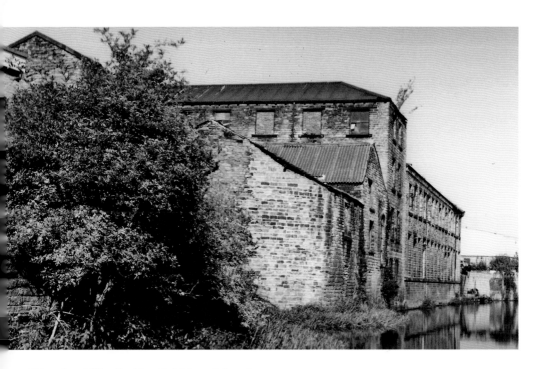

Waterloo Mills, Huddersfield Broad Canal
The canal route north from Huddersfield passed by various industrial establishments. Waterloo Mills provide a long frontage to the waterway. (*Ray Shill, 749591 & 749592*)

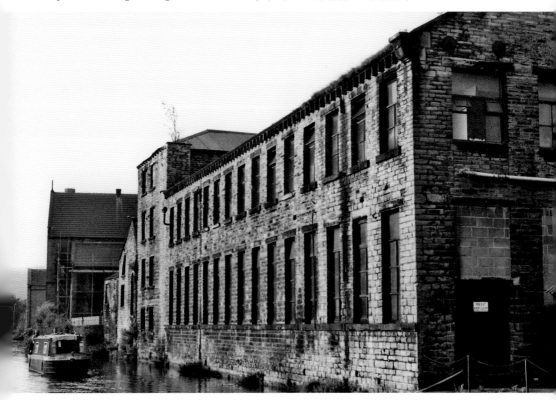

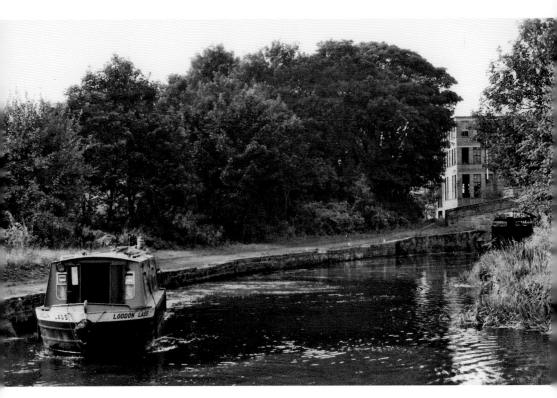

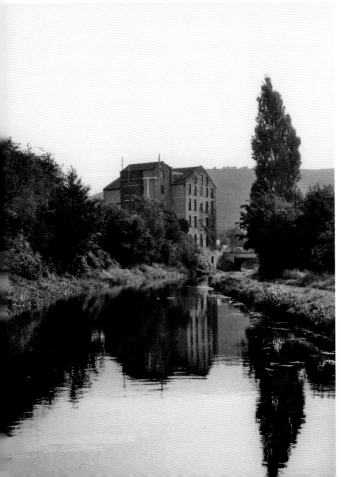

Joe Kayes Bridge and Deighton Mill, Huddersfield Broad Canal
Lock 3 (*upper image*) on this canal has been known as Johnson's Lock, and is now known as Ladgrave. The tail of the lock is crossed by a stone bridge (Joe Kayes Bridge). The lower image is a view along the canal to Deighton Corn Mill and Whittaker Bridge. (*Ray Shill, 75801 & 75790*)

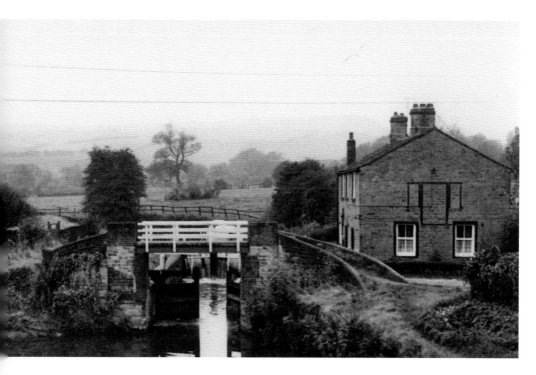

Lock 1, Huddersfield Broad Canal, Coopers Bridge, 1971 and 2000
The Huddersfield Broad Canal joined the Calder at Coopers Bridge. All craft had then to turn away from the weir for the Coopers Bridge Cut (for Wakefield) or head north towards Brighouse. (*RCHS Collection, 40047, & Ray Shill, 750975*)

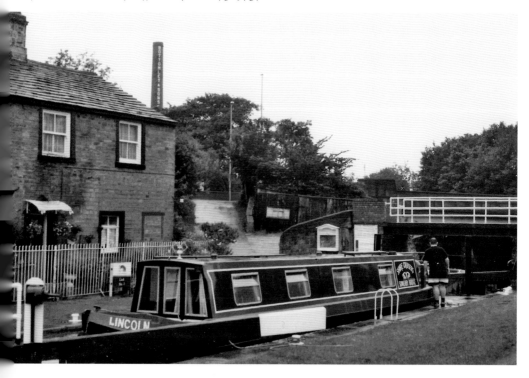

Chapter 4
Canal Links Between the Aire & Don

Barnsley Canal, Dearne & Dove Canal

The Barnsley Canal was engineered by William Jessop. His scheme provided for a barge canal from the Calder, east of Wakefield, through to Barnsley. This waterways trade was principally that of coal, although there was also significant merchandise traffic. The route climbed through locks to cross the Dearne, near Barnsley. It passed along the eastern and northern perimeter of the town, before finally climbing through five locks at Barugh to a terminus wharf and wharf at Barnby. John Pinkerton was the contractor appointed to construct this waterway. He came to this contract after a decade of mixed fortunes in canal building.

The Barnsley was subsequently leased and later purchased (in 1871) by the Aire & Calder Navigation, which made improvements to the section between Heath and Barnsley. In particular, the locks were enlarged and powers were obtained (although not carried out) for an incline plane to replace some of the Walton Locks.

West of Barugh, including the locks, a general traffic decline led to the official abandonment of the section to Barnby Basin (1893).

A water supply was provided by Cold Hiendley Reservoir, which delivered water into the summit above Walton Locks. This reservoir was enlarged and a second reservoir, Winterset, was later added to improve the supply as trade increased. Other supplies came in at Barugh and Barnby.

The junction with the Dearne & Dove Canal, which united the Barnsley Canal with the Don Navigation south of the Dearne aqueduct, was located at Barnsley. This waterway also passed through an extensive mining district, before joining up with the navigation to Mexborough and Sheffield. The main line comprised the length from Barnsley to Swinton, and there were branches to Worsborough and Elsecar, each having feeders from reservoirs.

The two Acts for the Dearne & Dove Canal and the Barnsley Canal were passed on the same day in June 1793. Construction began in 1793, under the charge of engineer Robert Mylne, although work proceeded slowly. It first opened to the junction with the Elsecar Branch in 1798. It was not until November 1804, that the canal was finished to join the Barnsley Canal.

While the Barnsley became part of the Aire & Calder system, the Dearne & Dove was acquired by the Don Navigation, and was subsequently part of the Sheffield & South Yorkshire Navigation.

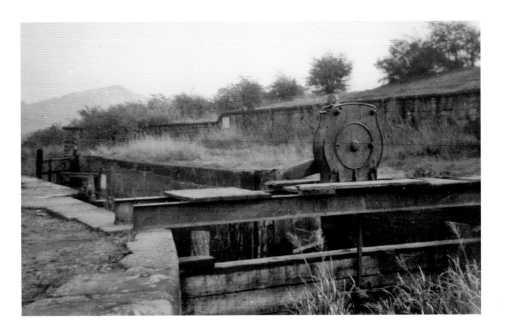

River Lock and Entrance at the Heath, Barnsley Canal
In 1815, the engineer Thomas Bradley made a report that was critical of the existing junction of the Barnsley Canal, and the Calder east of Wakefield. The first lock was set at the end of a cut from the river, although this cut was prone to silt up, which hampered navigation. On Bradley's recommendation, a new cut was made parallel, and west, of the old cut to a new lock at Heath, where craft might lock down directly into the river. This work was completed during 1816. (*RCHS Hugh Compton Collection, 64165*)

Canal Side Buildings, Lock 3, Barnsley Canal, 1967
There were two locks at Agbrigg, which were placed either side of the Wakefield–Pontefract Road. (*RCHS .K. Gardiner Collection, 66032*)

Lockhouses, Barnsley Canal, 1967
The upper image was a building placed near Lock 2 at Agbrigg. The building below is located beside the former Walton Lock flight. There were twelve locks in the Walton lock flight. The lock house was placed near Lock 6, 2 miles from the Calder. (*RCHS K. Gardiner Collection, 66034 & 66042*)

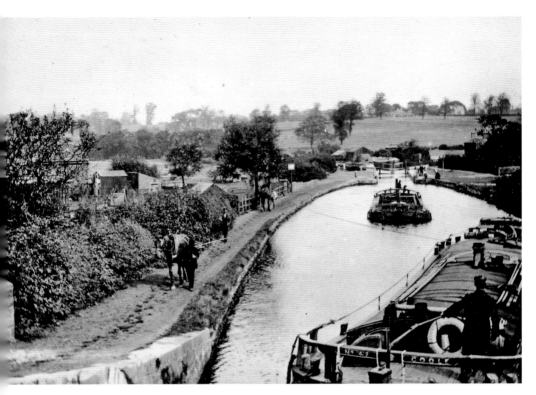

Above: **Walton Locks, Barnsley Canal**
This image has appeared in various publications, often captioned as being at the Heath. The location would appear to be on the Walton Lock flight, at a time after the locks were enlarged to the design of W. H. Bartholomew. (*RCHS Hugh Compton Collection, 64160*)

Right: **Corn Mill, Near Monk Bretton, Barnsley Canal**
(*RCHS K. Gardiner Collection, 66073*)

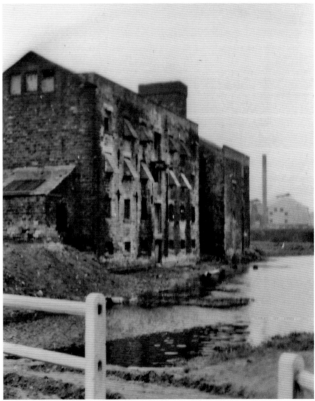

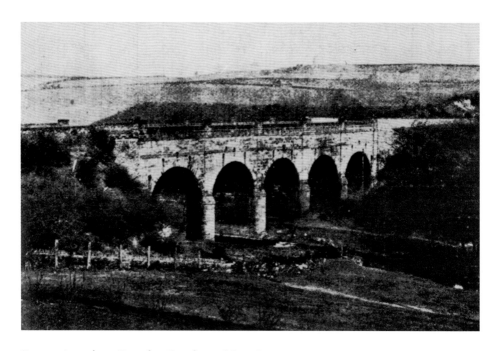

Dearne Aqueduct, Barnsley Canal, 1906 & 1967

The Barnsley Canal crossed the Dearne by a massive five-arch masonry aqueduct, built to the design of William Jessop by John Pilkington, his business associate and contractor. With the final closure of the Barnsley Canal, the aqueduct over the River Dearne was dismantled, but the piers were retained and later formed the base for a pedestrian footbridge. (*Above: RCHS Transparency Collection 53901. Below: K. Gardiner Collection, 66075*)

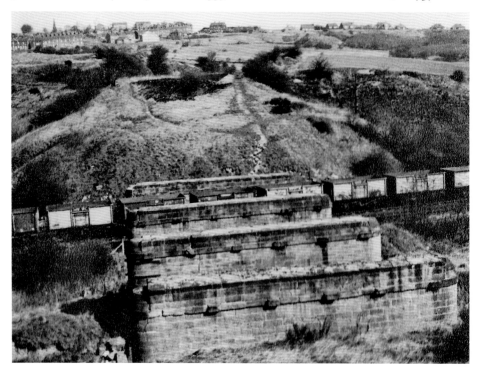

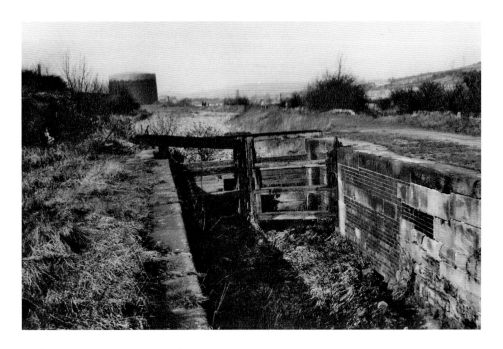

Lock 19, Dearne & Dove Canal
Lock 19, which formed a stop lock, can be seen in this view towards Barnsley. Beyond was the junction with the Barnsley Canal. (*RCHS K. Gardiner Collection, 66733*)

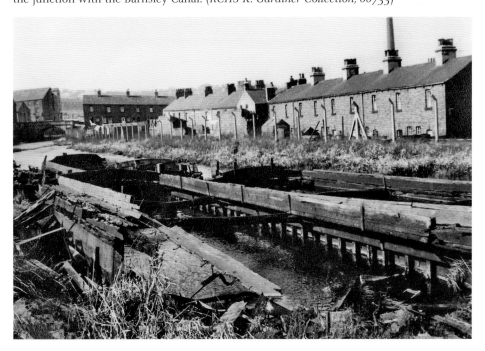

Disused Boats near Old Mill Wharf, Barnsley Canal
Further along the Barnsley Canal could be found Harborough Hill Road Bridge, the warehouses and a glassworks. Old boats were also stored here after the canal closed. (*RCHS K. Gardiner Collection, 66082*)

Old Mill Wharf, Barnsley Canal

There were large warehouse buildings at Barnsley (Old Mill Wharf) that survived after the canal ceased to be a navigation. (*RCHS K. Gardiner Collection, 66091, & RCHS Hugh Compton Collection, 64158*)

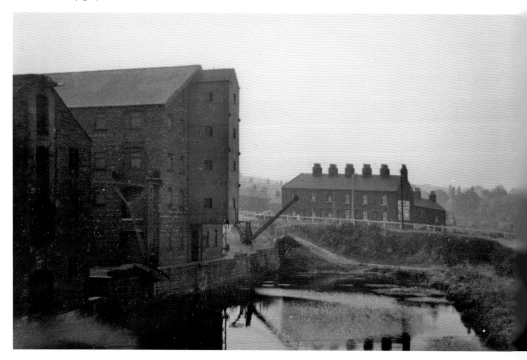

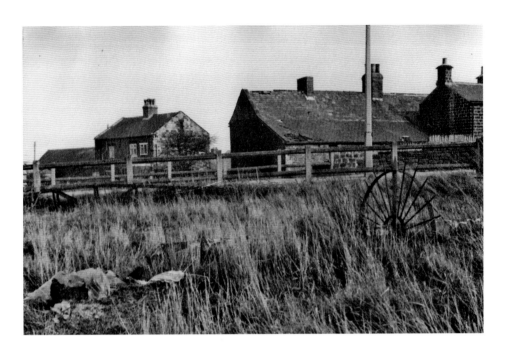

Barugh Locks, Barnsley Canal

There were five locks at Barugh that carried the canal up to the top summit level. The locks, and the section west to Barnby, were officially abandoned by an Act of Parliament in 1893, even though traffic had ceased some years earlier. (*RCHS K. Gardiner Collection, 66090*)

Barnby Basin, Barnsley Canal

Barnby Basin was the terminus of the Barnsley Canal, and the wharf for the Silkstone Railway, originally built to serve Barnby Furnace Colliery. The Barnsley Canal Co. was authorised to build a separate line, but decided to purchase and extend the Barnby Furnace line in 1808. This basin had limekilns and received water along a channel that connected with Silkstone Beck. (*RCHS Baxter Collection, 21802*)

Stairfoot, or 8, Locks, Dearne & Dove Canal
Canal contractors reached the bottom of the locks during 1799, although another five years were required to build the locks and finish the level section to Barnsley. (*RCHS K. Gardiner Collection, 66745 & 66747*)

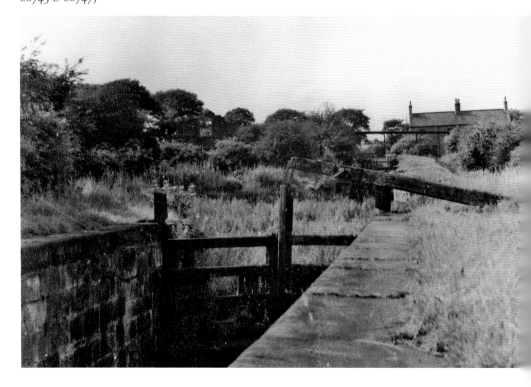

Brampton Locks, Dearne & Dove Canal
Brampton Locks are a flight of five, and at the top is Wombwell Junction where the Elsecar Branch joined the main canal. Much of the canal north of Manvers Main Colliery to Barnsley was abandoned from 1934. (*RCHS K. Gardiner Collection, 66783 & 66784*)

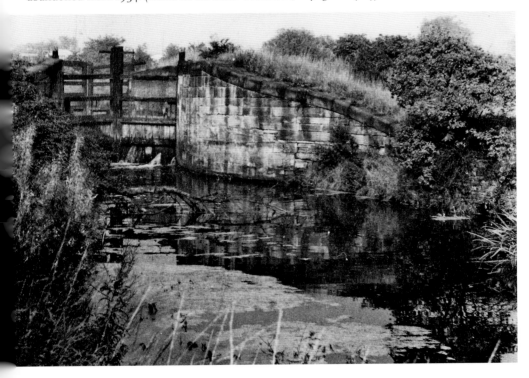

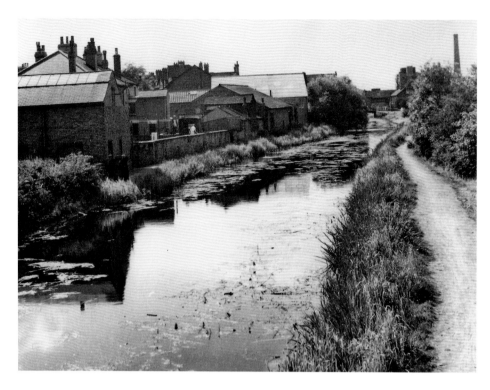

Wath Bridge and Manvers Main, Wath, Dearne & Dove Canal, 1959
The canal passed through Wath, where there were colliery loading points with Manvers Main Colliery. This section remained in use after nationalisation. (*RCHS K. Gardiner Collection, 66831 & 66828*)

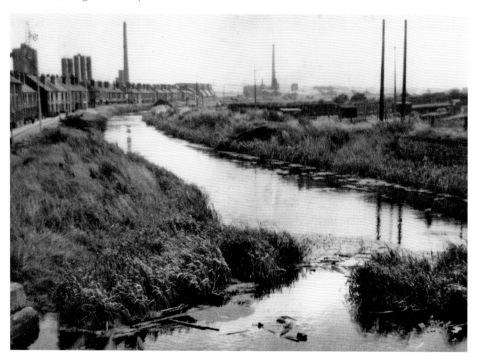

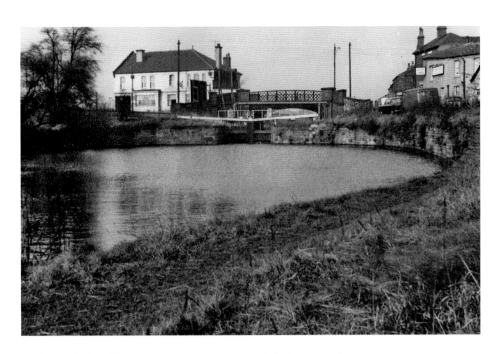

Lock 4 and the Ship Inn, Dearne & Dove Canal, Swinton, 1967
Both Lock 4 and the iron bridge remained part of the working navigation to supply water and material to the glassworks at Swinton. (*RCHS K. Gardiner Collection, 66841*)

Elsecar Reservoir, Dearne & Dove Canal, 1967
Elesecar Reservoir was fed by the Knoll Brook, and the feeder from here provided water to the Elsecar Branch and the main canal. (*RCHS K. Gardiner Collection, 66913*)

Waddington's Boat Yard and Site of Locks 3 & 2, Dearne & Dove Canal
There were six locks at Swinton. Waddington's boatyard used the former sites of Locks 1–3 as part of their boat maintenance yard. (*Above: Ray Shill, 869172. Below: RCHS K. Gardiner Collection, 66846*)

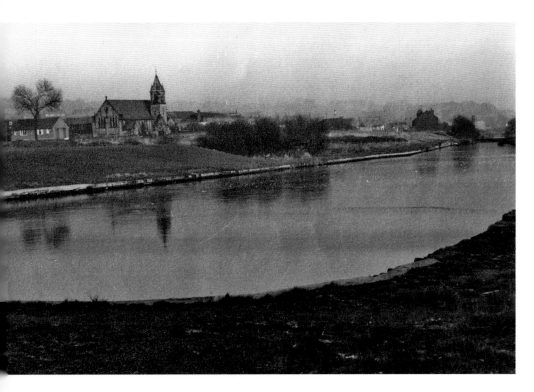

Boatmans Rest, Near Worsborough and Worsborough Basin, Dearne & Dove Canal
The Worsborough Branch was abandoned in 1906, but remained intact to supply water from the reservoir to the main canal. (*RCHS K. Gardiner Collection, 66932 & 66930*)

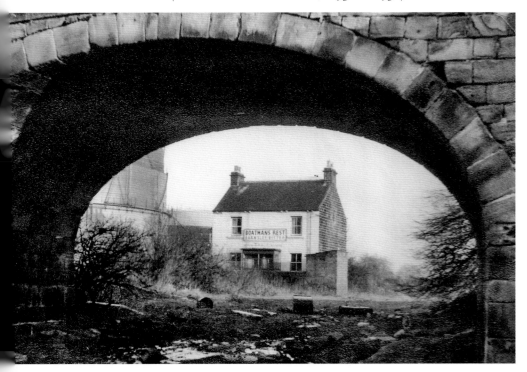

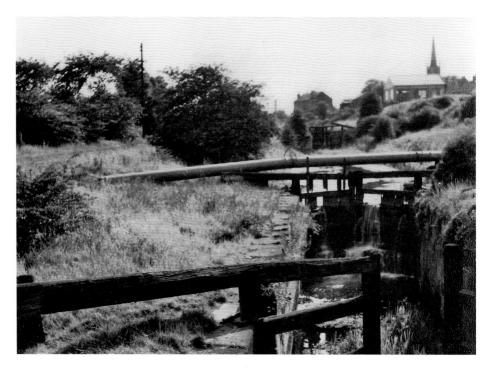

Locks, Elsecar Branch, Dearne & Dove Canal

The canal to Elsecar Basin was comprised of six locks. Finance for the branch was supplemented by Earl Fitzwilliam, whose ironworks at Elsecar was served by the canal. (*K. Gardiner Collection, 66861 & 66866*)

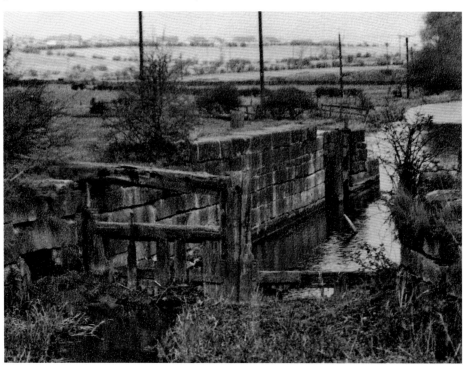

Chapter 5
Railway Structures and Ownership

The railways in this area were quite diverse, but principally included the Great Northern, Manchester, Sheffield & Lincolnshire Railway (Great Central), Lancashire & Yorkshire, London & North Western, Midland Railway and the North Eastern Railway.

Various constituent railways provided the finance for construction as the railway network formed around this region. Among the early railway schemes were the North Midland, which united Derby with Leeds, via Rotherham, and passed through the Barnsley district. Other lines, which have been mentioned in companion books, include the Manchester & Leeds, which passed through Sowerby Bridge, Mirfield and Wakefield. There was also the Huddersfield & Manchester Railway and Canal, which followed the Huddersfield Canals as far as Coopers Bridge. These routes passed respectively into the control of the Lancashire & Yorkshire Railway, and the London & North Western Railway companies.

The building of the Manchester & Leeds led to an intended diversion of the river at Healey Mills, which has been called the Healey New Canal, built around 1838. The railway course was altered prior to completion and the diversion was not needed.

Railway access to Sheffield provided a group of railways such as the South Yorkshire Railway, which merged with the River Don Navigation, to operate both navigation and railway networks. They became part of the Manchester, Sheffield & Lincolnshire Railway until 1894, when the navigation interests separated to form the Sheffield & South Yorkshire Navigation. Thus the Dearne & Dove Canal was in railway ownership from 1850–94.

The Huddersfield Narrow and Broad Canal were owned by the London & North Western Railway and their successors, the London, Midland & Scottish Railway. Prior to nationalisation (1944), the section of the Huddersfield Narrow below Lock 3 and all of the Broad Canal were taken over by the Calder & Hebble Navigation and became part of their network.

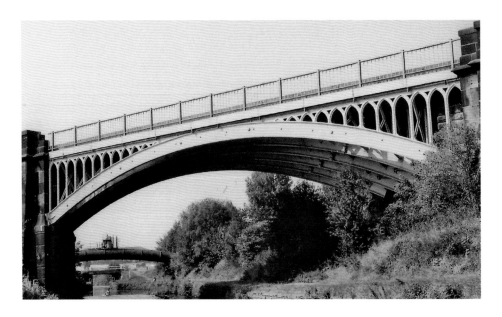

Leeds, Dewsbury & Manchester Railway, Skew Railway Bridge, Calder & Hebble Navigation
After crossing the Calder, the Leeds, Dewsbury & Manchester Railway passed over the Thornhill Lees Cut to join up with the Manchester & Leeds Railway at Ravensthorpe. Completed in 1848, this cast-iron railway bridge was built by Joseph Butler, of Stanningly Ironworks. It is Grade II listed. (*Ray Shill, 657911*)

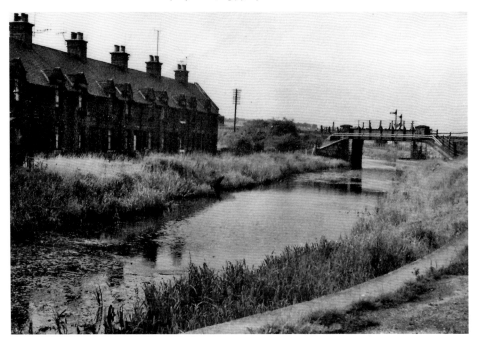

Midland Railway Bridge, Barnsley, Dearne & Dove Canal
The Midland Railway built a branch from Curdworth to Barnsley during the 1860s as part of a general upgrade of their service to Barnsley. (*RCHS K. Gardiner Collection, 66740*)

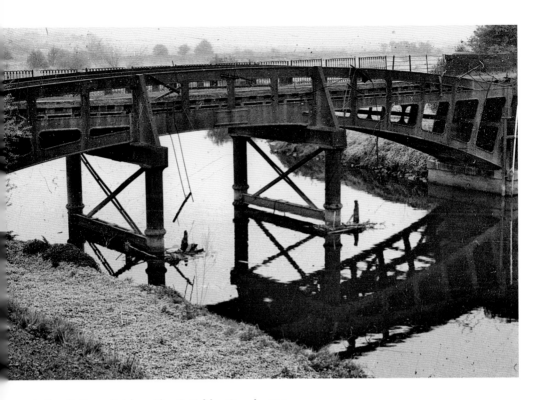

Astley Railway Bridge, Aire & Calder Canal, 1970
From a coal staithe placed beside the Aire & Calder, the railway ran north to various mines, including Allerton Main Colliery. (*RCHS Transparency Collection, 53101 & 53102*)

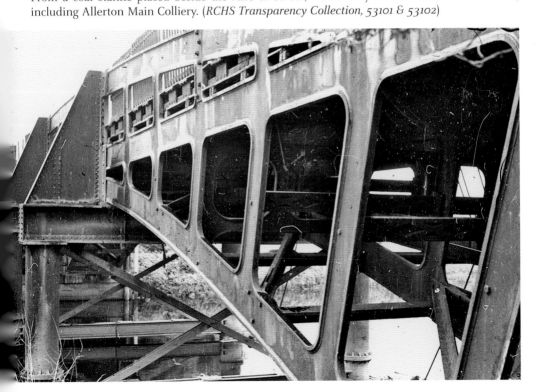

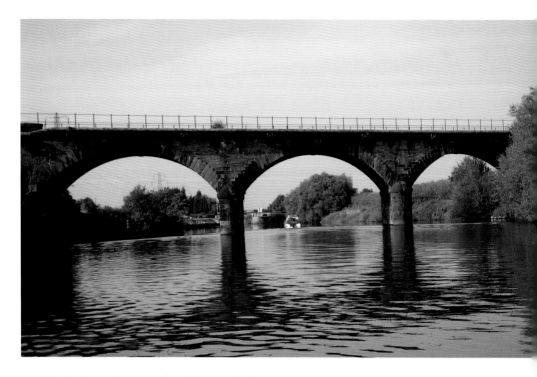

Methley Railway Bridges, Aire & Calder Navigation
The two bridges at Methley are both brick and masonry built. The upper image shows the Calder Bridge, which was built for the North Midland Railway, with one arch spanning 90 feet and another five arches at 60 feet. The lower image shows Stephenson's bridge, which carries the Leeds Extension Railway over the river. (*Ray Shill, 603501 & 603511*)

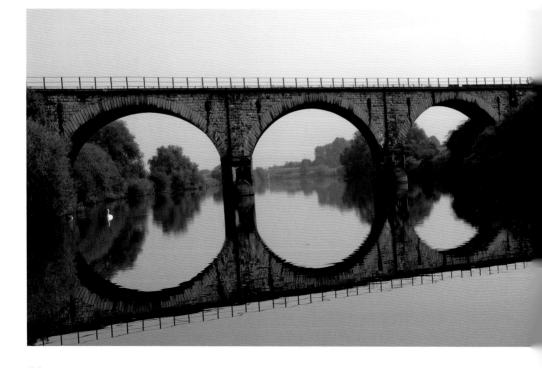

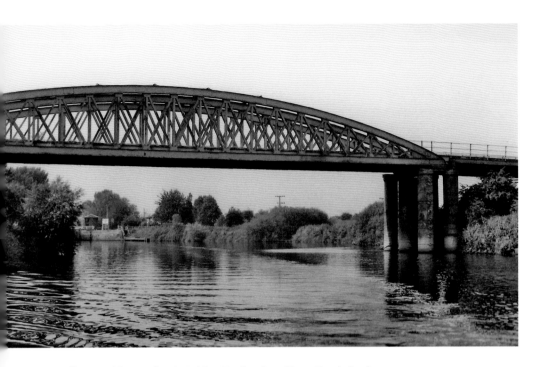

NER Railway Bridges, Aire & Calder Navigation, Near Castleford
Leeds Castleford and Pontefract Junction Railway opened in 1878. Its span is 162 feet, and it is supported on cast-iron cylinders. (*Ray Shill, 603402*)

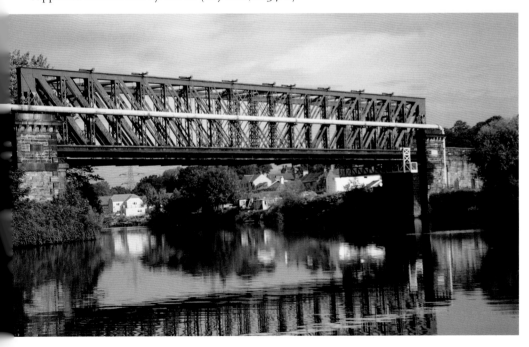

Brotherton Bridge, Ferrybridge, Aire & Calder Navigation
The Brotherton Bridge was first built as a tubular bridge, but has been subsequently opened out. (*Ray Shill, 603611*)

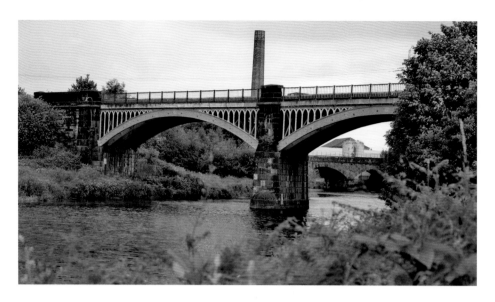

Leeds, Dewsbury & Manchester Railway Bridge, River Calder, Calder & Hebble Navigation
Long before the railways came to Dewsbury, there was navigation along the Calder. Boats had reached this area during 1762, and within two years were heading upstream to Brighouse. Whilst the through route was bypassed by the Thornhill Cut from 1798, boats still travelled along this section to Raven's Wharf and the Dewsbury Cut. The attractive iron and stone bridge was built to carry the Leeds, Dewsbury & Manchester Railway over the river. Before opening, this line became part of the London & North Western Railway system. It remains part of the national railway system. The bridge behind carried the later Lancashire & Yorkshire Railway Spey Valley line, though is now disused. (*Ray Shill, 660321*)

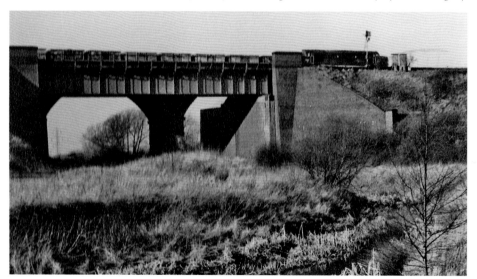

Midland Railway Bridge, Barnsley Canal
The North Midland Railway route from Derby to Leeds passed through an extensive mining district and crossed the Barnsley Canal at two points. George and Robert Stephenson were joint engineers for the line, with John Stephenson the contractor for the Swinton contract (Rotherham–Pontefract). (*RCHS K. Gardiner Collection, 66048*)

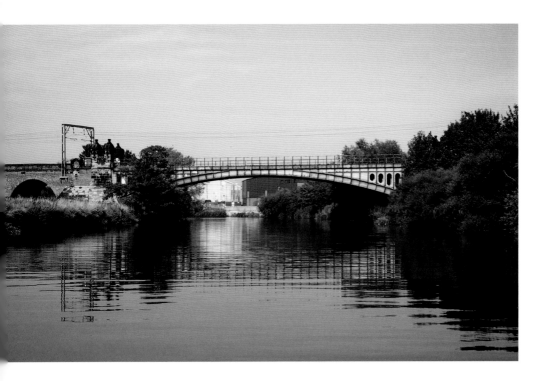

Wakefield Railway Bridge, GC & GN Joint, Aire & Calder Navigation, 2006
The West Riding & Grimsby Railway (Great Central & Great Northern Joint Railway) spans the Calder and Lancashire & Yorkshire Railway (LYR) by a ninety-five-arch viaduct, 1,200 feet in length. That which spans the river is formed of iron and spans 163 feet. The line was opened in 1866. (*Ray Shill, 658801*)

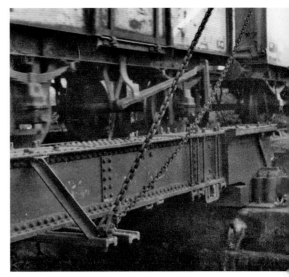

Railway Lift Bridge, Dearne & Dove Canal
The Great Central (Manchester, Sheffield & Lincolnshire Railway) branch line to Elsecar crossed the Dearne & Dove Canal between Locks 8 and 9 on the canal. (*RCHS K. Gardiner Collection, 66802 & 66803*)

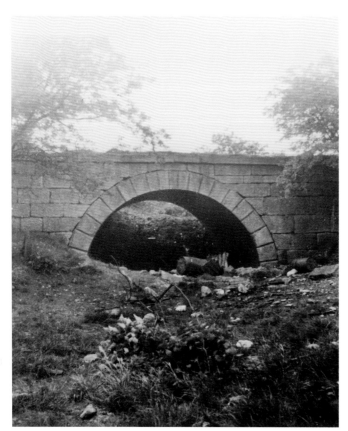

Left: **Heck & Wentbridge Railway**
The railway from Wentbridge was constructed for stone traffic, but never completed. (*RCHS Baxter Collection, 20870*)

Below: **Port of Goole, Aire & Calder Canal**
Goole was first an inland canal port, but, with the completion of railway links joining it, transhipment of coal from railway wagons directly into seagoing and coastal vessels became an important aspect of the port's operation. (*Ray Shill, 605511*)

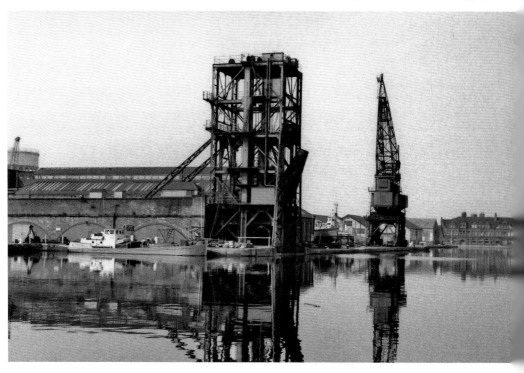

Plateway Rail and Section of Track, Silkstone Railway
The Barnsley Canal Co. built a plateway from Barnby Canal Basin to Silkstone. (*RCHS Baxter Collection, 21804 & 21792*)

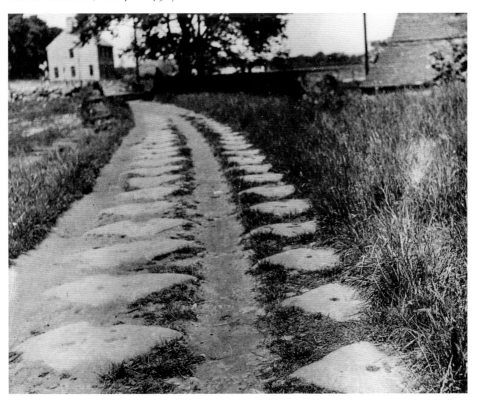

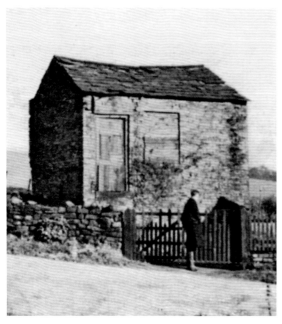

Engine House, Stampers Hill Incline, Worsborough Railway
The Worsborough Railway was a tramway that ran from ironstone and coal mines near Silkstone, including Silkstone Main Colliery, to the Worsborough Basin (Dearne & Dove Canal). (*RCHS Baxter Collection, 22196*)

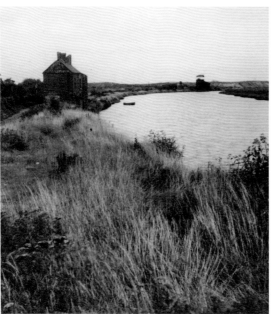

River Calder Wharf, Wakefield (Outwood) Railway
The 4 foot 5 inch gauge railway from the Wakefield Outwood Collieries to Bottom Boat on the Calder (Aire & Calder Navigation) was completed during 1823. The engineer George Leather was responsible for surveying the route. (*RCHS Baxter Collection, 22089*)

Chapter 6

Navigation Improvements and the Port of Goole

The Calder & Hebble and Aire & Calder Navigations had various and substantial diversions of route to accommodate trade. The increasing size of craft, particularly for coal traffic, was of high importance in this respect. A key factor in all these works was the input of a number of engineers. John Rennie investigated potential improvements to the Aire & Calder and was responsible for planning the Knottingley to Goole Canal. Thomas Telford's scheme formed the basis of the improvements from Wakefield to Castleford, while George Leather devised many of the new cuts from Kippax to Leeds. Thomas Bartholomew was resident engineer and also had significant input as work proceeded. His son, William Hamond Bartholomew, succeeded him and perhaps made the most important engineering contributions, improving the navigation by extending locks to a sufficient length to accept trains of compartment boats between Castleford and Goole. He was a keen supporter of mechanisation and installed improved mechanical handling at goods warehouses and the port of Goole.

With the Calder & Hebble, William Bull made further new improvements that included the Horbury & New Broad Cut, as well as new locks on the Thornes Cut. The twenty-one-year lease, by the Aire & Calder Navigation, enabled William Bartholomew to make further improvements to this waterway. This included the lease of the disused Old Dewsbury Cut, which had been purchased by Lord Savile from the Calder and Hebble, as far as Savile Town, where a new basin and warehouse was built. The link to the Calder and the Old Lock at Cut End was occupied by Cut End Mill, but part of the old canal was retained as a mill pond and there was also a private Savile Wharf on this section, which joined up with the Aire & Calder leased canal. A later alteration involved the diversion of the Aire in Leeds between Thwaite and Hunslet and the removal of Thwaite Lock. This reconstruction also brought the Waterloo Main Colliery Staithes within the canal navigation.

Aire & Calder Improvements

These improvements included the 1826 Knottingley and Goole Canal; 1836 Castleford–Leeds; 1839 Broad Reach–Stanley; Ferry–Castleford; 1842 Leeds Cut widening and New Basin (Clarene Dock) and, in th 1860s, the increase of the lock size to serve compartment craft. The Aire & Calder Act (1895) enabled the diversion of the Aire at Knowstrop and included various widenings of the canal to Goole.

Calder & Hebble Improvements

Taking place in 1838 at Horbury and Broad Cut, these included the lock doubling, enlargement at Thornes and at Battye Lock.

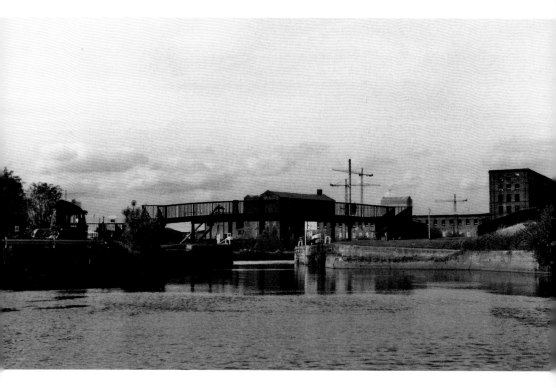

Knowstrop Flood Lock, Aire & Calder Canal
This lock was the entrance to the Knowstrop Cut from the Aire, which originally flowed to the left and the weir at Hunslet Mill. The River Aire was diverted to the right along a new course parallel with the Knowstrop Cut, with the work being finished during 1905. (*Ray Shill, 606505 & 606506*)

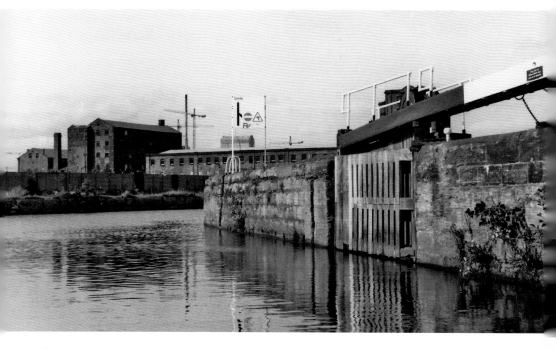

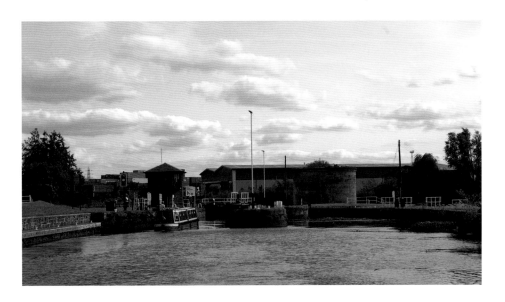

Knowstrop Falls Lock, Aire & Calder Navigation
The canal at Knowstrop has changed over the years. A simple cut from Knowstrop to Hunslet avoided the original lock at the weir for Hunslet Mills. With improvements to the navigation (in the 1830s), boats reached the river via the Thwaite flood lock and crossed it to Knowstrop. Further improvements during the twentieth century included the diversion of the Aire and the uniting of the Knowstrop Cut with the one from Thwaite via Woodlesford to Kippax. The central pier once supported the Great Northern Railway bridge, which carried their railway to Hunslet Goods, and was completed in 1899. (*Ray Shill, 606621*)

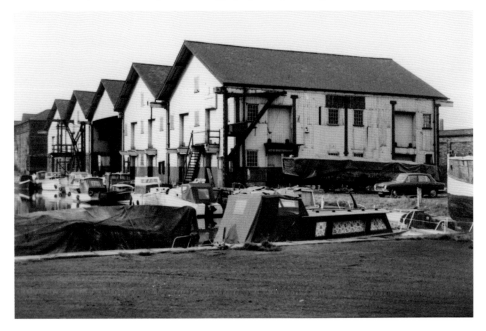

Savile Town Wharf, Dewsbury Cut, Aire & Calder Navigation
In order to handle their trade, the Aire & Calder Navigation built a new wooden warehouse at Dewsbury. (*RCHS Collection, 40060*)

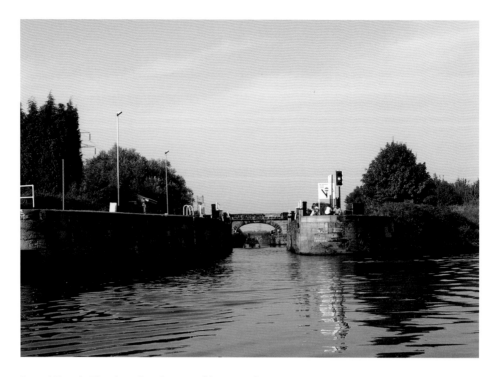

Broad Reach Flood Lock, Aire & Calder Canal
Thomas Telford was responsible for engineering the route between Broad Reach and Woodnock Lock. This straight canal involved the making of three new locks, which replaced the three original lock cuts at Kirkthorpe, Lake and Penbank. (*Ray Shill, 610078*)

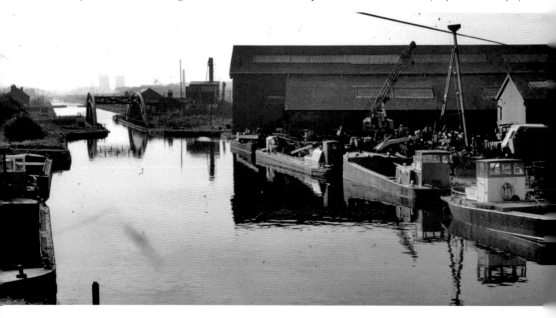

Stanley Ferry, Aire & Calder Canal
Stanley Ferry Aqueduct, across the former Calder Navigation, formed part of the new route. (*RCHS Transparency Collection, 53051*)

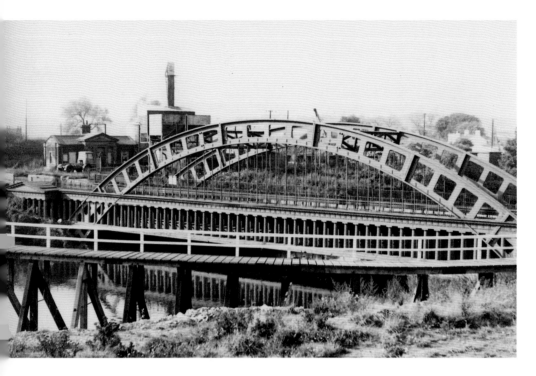

Stanley Ferry Aqueduct, Aire & Calder Canal
The cast-iron aqueduct at Stanley Ferry was suggested by Thomas Telford, although it wasn't completed until after his death. Upriver from the aqueduct was a curved timber walkway, which was removed when British Waterways arranged for the construction of a new aqueduct. (*RCHS Hugh Compton Collection, 64021, & Ray Shill, 610153*)

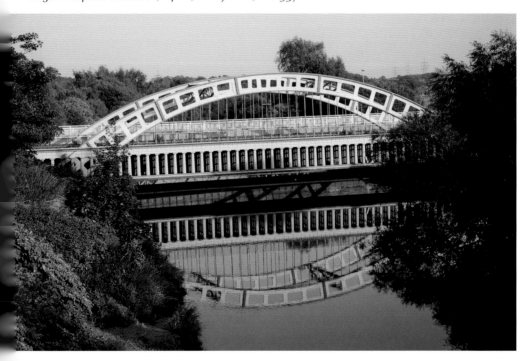

Kings Road Lock and Woodnock Lock, Aire & Calder Canal
Birkwood, Kings Road and Woodnock formed the three new locks completed in 1839, with the new link from Broad Reach. (*Ray Shill, 610312 & 610452*)

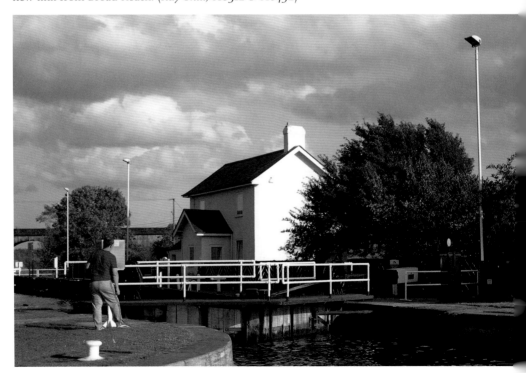

Fairies Hill Lock, Aire & Calder Canal
An alternative navigation to Woodnock Lock was the side cut through Altofts Locks and Fairies Hill Lock. (*Ray Shill, 612058*)

Bullholme Lock, Castleford, Aire & Calder Canal
The approach from the Aire to Bullholme and the lock cut through Castleford. All locks from Bullholme through to Pollington were widened from 1862, to the design of William Bartholomew, for compartment boat traffic. Bulholme was enlarged further between 1892 and 1893. The present dock has elements of the original and subsequent improvements. (*Ray Shill, 603386*)

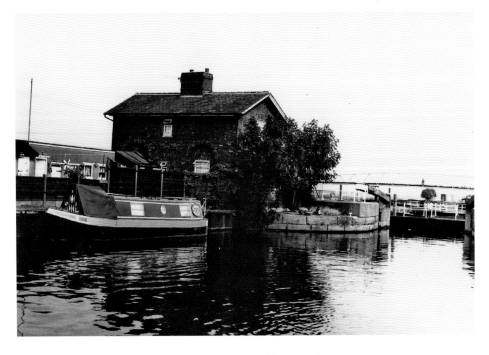

Bank Dole Lock, Lock House and Cut, Aire & Calder Canal
Bank Dole Lock and Cut formed the link between the Knottingley & Goole Canal and the River Aire. It allowed craft to travel on to Selby. (*Ray Shill, 612101*)

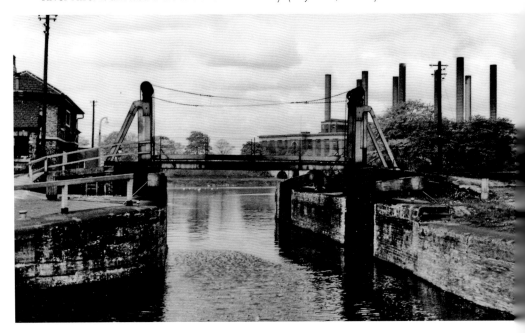

Ferrybridge Flood Lock, Aire & Calder Canal
Ferrybridge marked the start of the Knottingly and Goole Canal. This lock was enlarged from time to time, especially after the introduction of compartment boats to Goole. (*RCHS Hugh Compton Collection, 64012*)

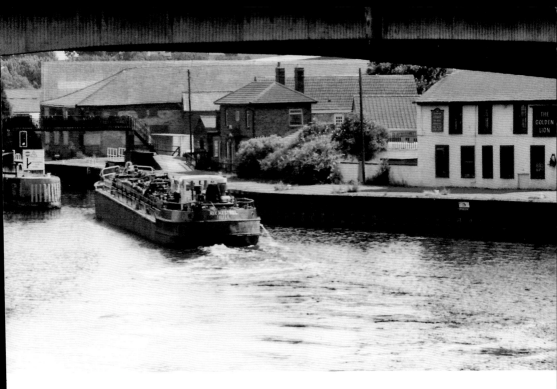

Ferrybridge Flood Lock, Aire & Calder Canal
Ferrybridge flood lock was enlarged in 1864, and again, later, to accommodate boat traffic. (*Ray Shill, 603701 & 603704*)

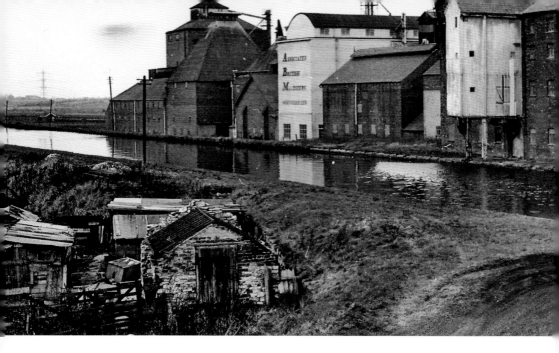

Whitley Bridge, Aire & Calder Canal
The roads and turnpikes that linked Selby with Doncaster crossed the Aire & Calder at Whitley Bridge. Warehouses were erected here, and there was also a group of malthouses and maltkins. The canal here was widened during the late 1890s. (*K. Gardiner Collection, 66007*)

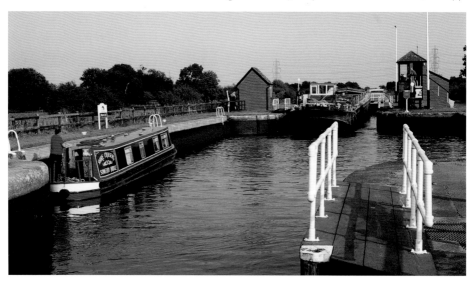

Pollington Lock, Aire & Calder Canal
The decision to have a train of boats that brought coal from the collieries was made during the 1860s. Between 1860 and 1864, lock chambers 260 feet long were constructed on the navigation lying between Castleford and Goole. Many had irregular shaped chambers to hold the group of boats. Pollington Lock was converted during 1861 and further improvements were made during 1898, where the canal was widened towards Goole. (*Ray Shill, 604562*)

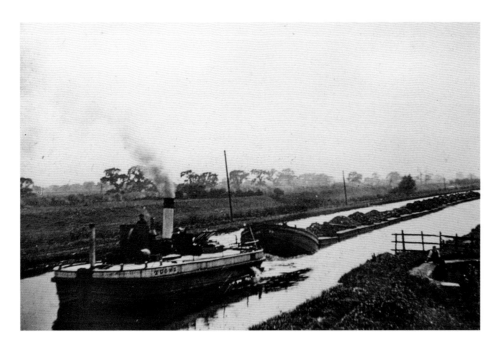

Tugs and 'Tom Puddings', Aire & Calder Canal

During the 1860s, the concept of specially built boats propelled, or towed, by steam tugs was adopted. These craft, known as 'Tom Puddings' were moved in 'trains' of usually eleven or twelve craft. If propelled by the tug a specially designed leader boat, or jebus, was placed at the front. If towed, the jebus was placed beside the tug. (*RCHS Cadbury/Severn Canal Carrying Collection, 81075, & RCHS Collection, 40001*)

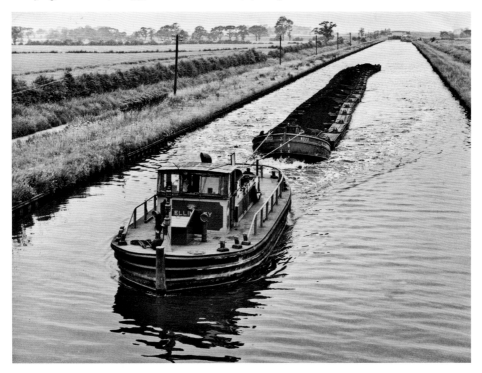

Port of Goole, Aire & Calder Canal

There were a group of basins at Goole that were added to as trade increased. Among the first were the Barge Dock, Ship Dock and Harbour (of 1826), which were linked to the Ouse by a barge and a ship lock. Ouse Dock was opened in 1836, with a separate lock to the Ouse. Railway Dock was made in 1848. Then there was Aldham Dock (1881), Stanhope Dock (1891), South Dock (1910) and West Dock (1912). The movement of earth from the Stanhope excavation was carried out using a light railway and a steam locomotive. (*RCHS Post Card Collection, 95043 & 95041*)

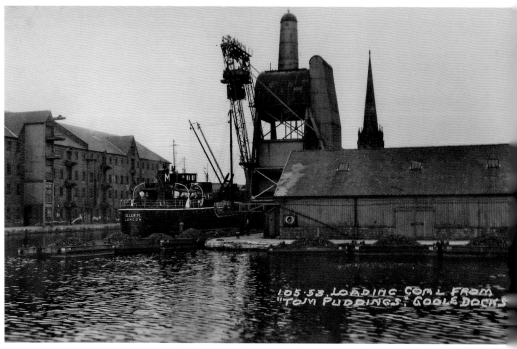

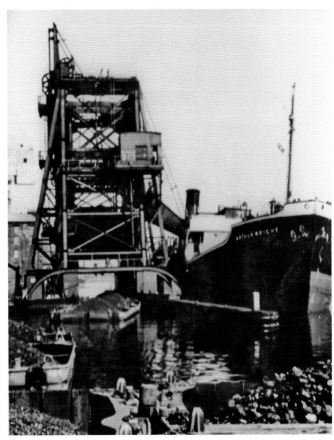

Loading Tom Puddings, Port of Goole, Aire & Calder Canal
Goole became an important shipping port for coal brought by the canal. W. H. Bartholomew revolutionised this trade with the introduction of compartment boats, commonly known as 'Tom Puddings', which transferred their cargo to coastal shipping with the aid of mechanical hoists. A total of five hoists came into use there. (*RCHS Photograph Collection, 40010 & 95042*)

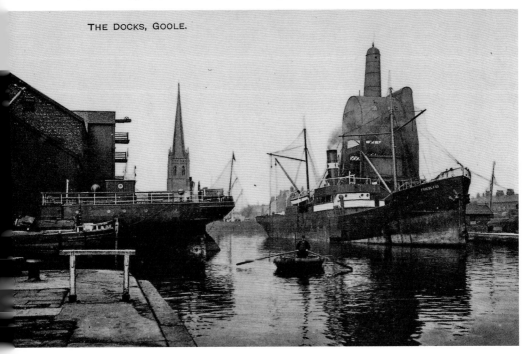

THE DOCKS, GOOLE.

Horbury Old Lock, Calder & Hebble Navigation

When William Bull became engineer to the Calder & Hebble in 1834, his contribution included the Horbury and New Broad Cuts that joined up with the 'Long Cut' to Thornhill at the original figure of three lock. A new side cut was made at Horbury Bridge, where craft could lock up onto the Calder and either pass upstream to the Healey New Mills or downstream via the Horbury Cut and lock that by passed the weir. (*Ray Shill, 660805*)

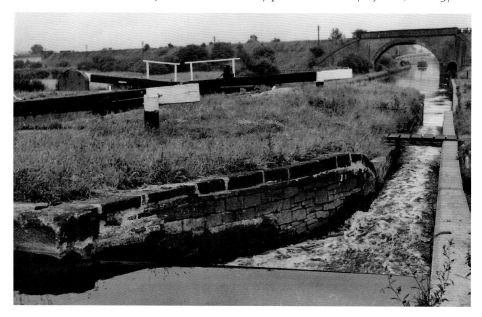

Broad Cut Upper Lock, Calder & Hebble Navigation

The original Broad Cut was replaced by a parallel and wider cut that joined up with the figure of three locks via Horbury Bridge, eliminating a river section and the lock at Wykeham. (*RCHS K. Gardiner Collection, 66145*)

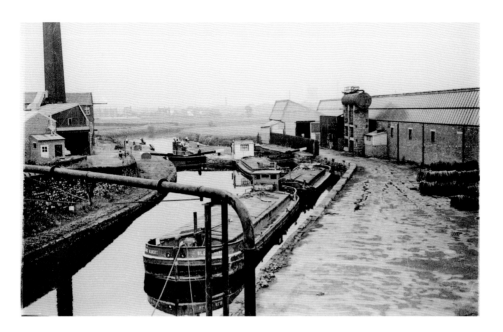

Thornes Locks, Calder & Hebble Navigation
At first, the lock at Thornes Cut comprised a single chamber. During the 1830s, when Bull was engineer, Thornes Lock was replaced by a pair of locks side by side. Further improvements were made in the period, during which the Aire & Calder Navigation Co. leased the waterway. They increased one lock in length to enable larger craft to proceed upstream. (*RCHS K. Gardiner Collection, 66171*)

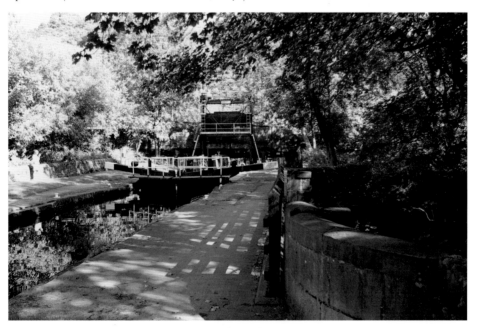

Salterhebble Bottom Lock, Calder & Hebble Navigation
The bottom lock at Salterhebble was reconstructed during 1938 following a road-widening scheme. The tail gates were replaced with a guillotine gate. (*Ray Shill, 656235*)

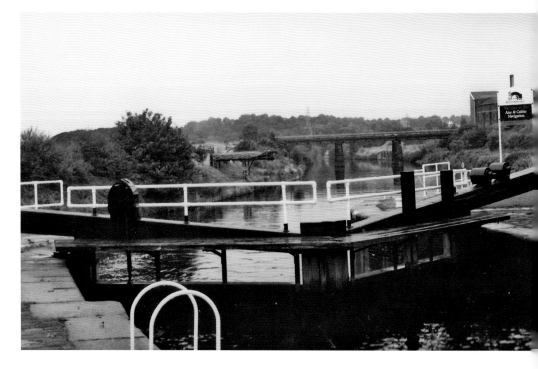

Fall Ings Lock, Calder & Hebble Navigation

The Calder & Hebble loacks at Fall Ings enabled craft to pass to and from Broad Reach of the Calder. The first connection was replaced by two locks. These, in turn, were repaced by the present single lock. In the upper image, the view is from this lock towards the river and the Lancashire & Yorkshire Railway Bridge. In the lower image, the view is upstream to the lock (*left*). The other Fall Ings Lock entrance to the Aire & Calder Wharf was on the right. (*Ray Shill, 658991 & 658996*)

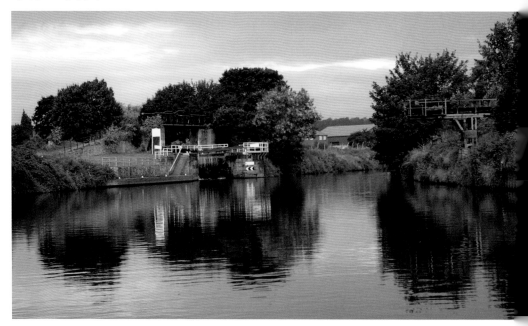

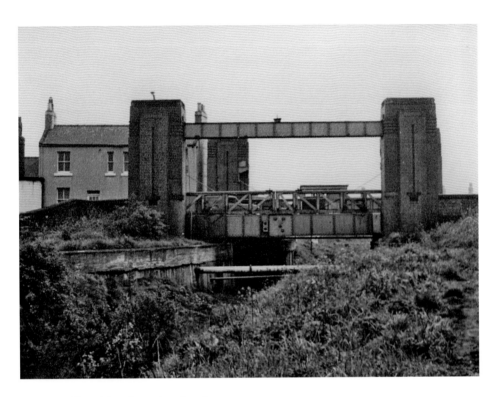

Royston Lift Bridge, Barnsley Canal
The electrically powered Lift Bridge at Royston was installed during 1934. (*RCHS K. Gardiner Collection, 66069 & 66070*)

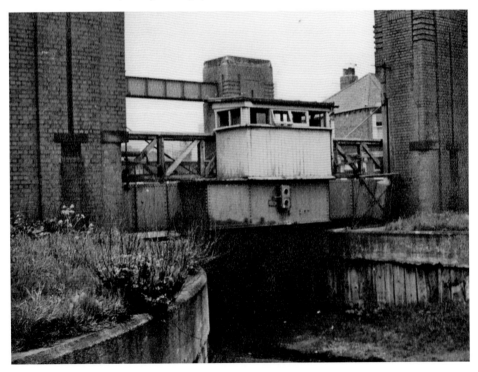

Chapter 7
Nationalisation, Restoration and Trusts

The navigations covered in this book were generally taken over by the Docks & Inland Waterways Executive, North Eastern Division.

The Transport Act, which came into force on 1 January 1948, led to Aire & Calder Navigation, the Calder & Hebble Navigation and the Sheffield & South Yorkshire Navigation, all passing into a nationalised transport network. They were, at the time, one of the busiest parts of that network.

At the point of nationalisation, parts of the Barnsley and Dearne & Dove Canals closed. The Barnsley was navigable to Barnsley Bridge and Barnsley Old Mill Wharves, while the Dearne & Dove was only navigable to the tail of Lock 7. Both branches, and the one above Barnsley, were classed as unnavigable through lack of maintenance.

The Barnsley was abandoned in 1953, although parts were used by the National Coal Board for a water supply. The Dearne & Dove was officially abandoned in 1961, though the section up to Lock 4 remained in use for local traffic.

British Waterways invested in further lock improvements, including mechanisation and new warehouses on the former Aire & Calder between Leeds and Goole. Traffic on the Calder & Hebble gradually declined, and was eventually limited to the section east of Dewsbury. This part of the Calder & Hebble, as well as the Aire & Calder, was classified as Commercial Waterways under the 1968 Transport Act.

Traffic in coal gradually declined as mines closed, and all Tom Pudding traffic to Goole ceased. There remained coal traffic to Ferrybridge Power Station, although this has since ceased. Oil and aggregate traffic has been retained along the Aire & Calder as far as Leeds and Whitwood Wharf.

The Huddersfield Broad Canal remained open for boating trade, although there were periods when weed growth effectively stopped boaters venturing up the canal from Coopers Bridge. Following the reopening of the Huddersfield Narrow Canal (2002) and Rochdale Canal (2001), boating increased on the Huddersfield Broad and Calder & Hebble Navigations.

Since 2012, the waterways have been part of the Canal & River Trust, which maintains and manages the remaining commercial trade and the growing boating trade.

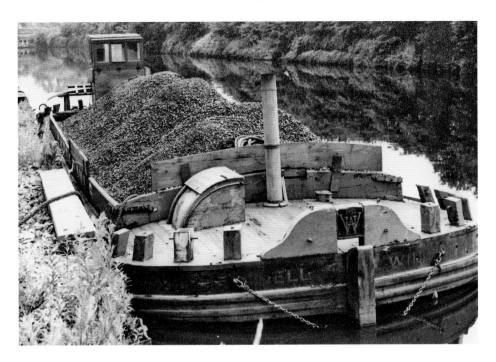

West Country Keels near Figure of Three Locks, Calder & Hebble Navigation
Most commercial trade on the Calder & Hebble ceased during the 1950s, but coal traffic to Thornhill Power Station was retained until the 1980s. This keel, the William Hibbell, was a modern non-tidal craft built at Mirfield Boat Dock. (*RCHS K. Gardiner Collection, 66140*)

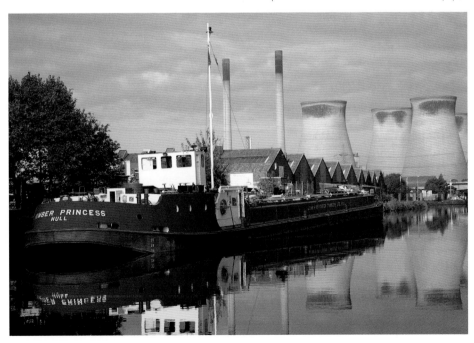

Oil Traffic, Ferrybridge, Aire & Calder Navigation
Traffic in oil passes up the canal to Ferrybridge or Leeds. (*Ray Shill, 603715*)

Stanley Ferry, New Aqueduct, Aire & Calder Canal, 1981
British Waterways built a new aqueduct at Stanley Ferry, adjacent to the original iron structure, as part of the general commercial improvement to this waterway. (*RCHS Transparency Collection, 53055 & 53056*)

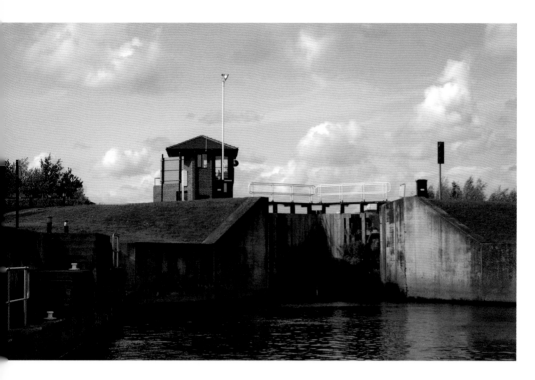

Lemonroyd New Lock, Aire & Calder Navigation
A new deep lock was constructed by British Waterways as part of the navigation improvements of the 1990s. The navigation was diverted onto an altered river course and the lock at Kippax removed. (*Ray Shill, 607205 & 607215*)

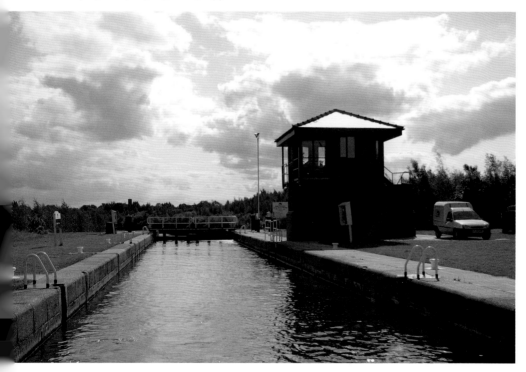

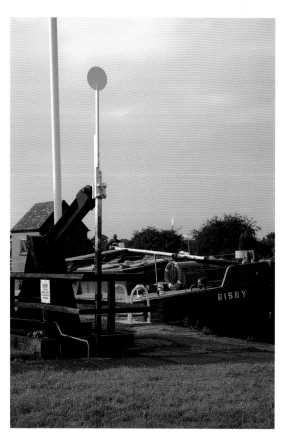

Left: **Lock Mechanisation, Pollington Lock, Aire & Calder Canal, 2006**
The mechanisation of locks was an important aid to commercial traffic, as well as serving the needs of the boater. Trading vessels pass the locks, aided by waterways staff who man the control cabin. Boaters have access to the lock side control panels that also operate the gates. (*Ray Shill, 604563*)

Below: **Whitwood Below: Aggregate Wharf, Aire & Calder Canal, 2006**
Whitwood Wharf is a modern wharf, built to receive aggregate traffic brought in by barge. (*Ray Shill, 610520*)

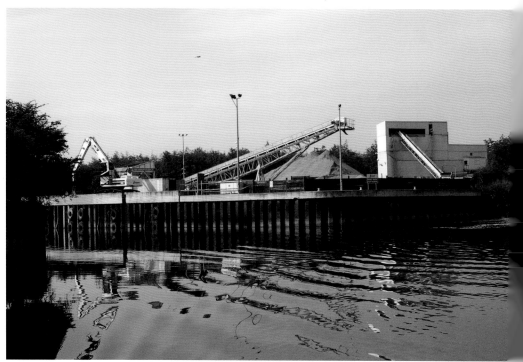

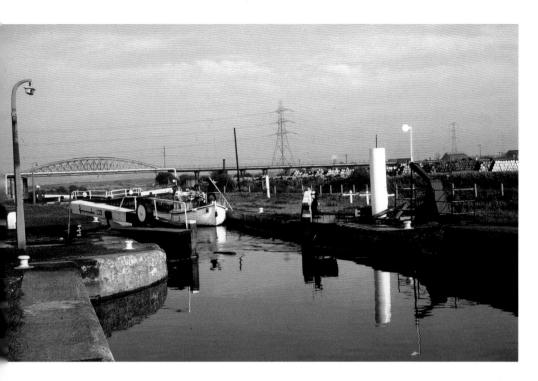

Castleford Cut, Bullholme Lock, Aire & Calder Canal, 1971
(*RCHS Transparency Collection, 53124*)

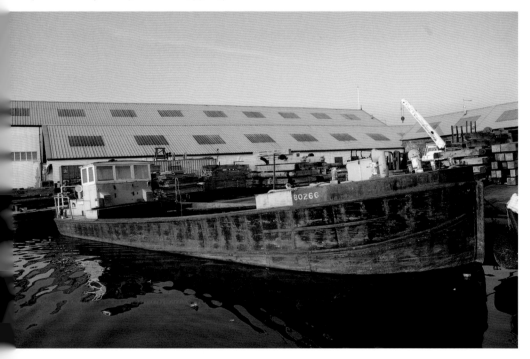

Stanley Ferry Workshops, Aire & Calder Navigation, 2006
(*Ray Shill, 610201*)

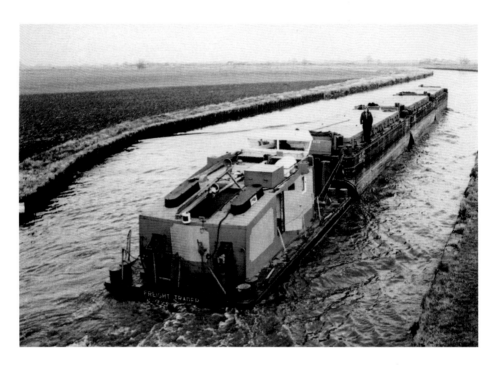

Freight Trader, Aire & Calder Canal
British Waterways introduced various schemes for competitive trade along the North East waterways. (*RCHS Postcard Collection, 95024*)

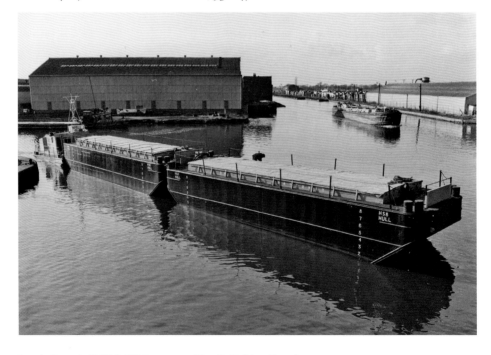

Leeds Depot, British Waterways, Aire & Calder Canal
British Waterways built a new depot at Leeds to replace the earlier depots in the centre of Leeds. (*RCHS Collection, 40934*)

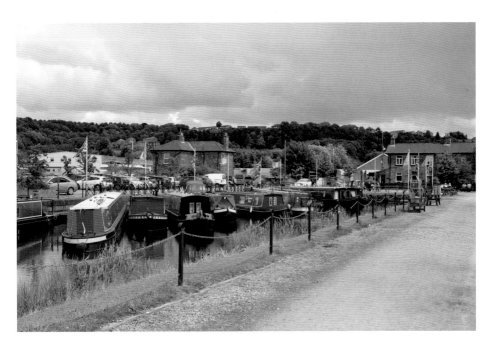

Savile Town Basin, Aire & Calder Navigation, Dewsbury Branch, 2014
Savile Town Basin was a commercial carrying depot for the Aire & Calder Navigation and their successors, British Waterways. When traffic ceased, the basin became a boat yard, but more recently has become residential moorings. (*Ray Shill, 607910*)

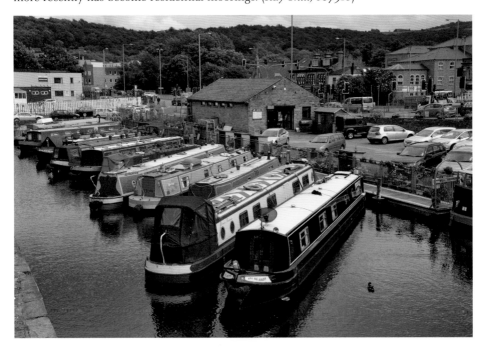

Apsley Basin, Huddersfield Broad Canal, 2014
Apsley Basin has been rejuvenated in recent years and now provides residential moorings for boaters. (*Ray Shill, 749520*)

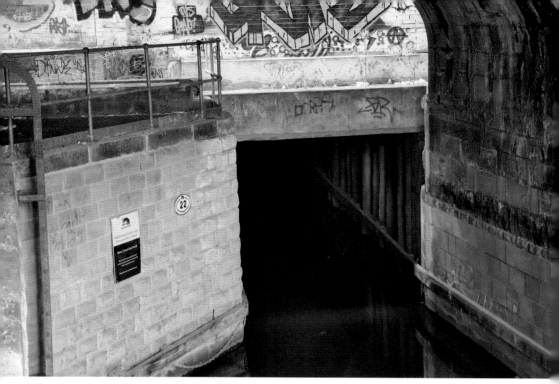

Above: **Lock 2E & Bates Tunnel, Huddersfield Narrow Canal**
Lock 2E was opened in 2001 and, due to its location on mill sites (Bates & Britannia), can only be accessed by boats and their crews. The towing path directions follow the roads around the perimeter of these mills. The wall piling and concrete roof formed the structure of Bates and Sellers Tunnel, as well as the excavated channels whenever a lock was repositioned. The 100-yard-long Bates Tunnel is now the only remaining tunnel in the Huddersfield restored section. (*Ray Shill, 774905 & 774902*)

Left: **Bates Tunnel Channel, Huddersfield, Huddersfield Canal**

Deepened Channel, Huddersfield, Huddersfield Canal
Two views looking away from (*above*) and towards (*below*) Queen Street South and Bates Mill. The restoration scheme completed in 2001 required the digging out of the canal bed from Bates Tunnel to the chamber of the original Lock 2E. (*Ray Shill, 774906 & 774907*)

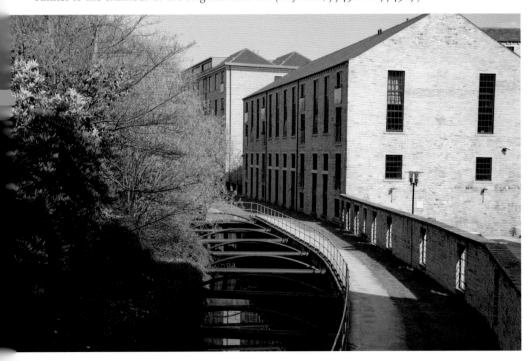

Notable Structures on North East Canals

Grid references are quoted for locations, and for tunnels and embankments/reservoir feeders from West to East (W–E) or North to South (N–S).

Railway Company Abbreviations:

GC	Great Central (Manchester, Sheffield & Lincolnshire)
GC &GNJ	Great Central & Great Northern Joint
GNR	Great Northern
HBR	Hull & Barnsley
HMRC	Huddersfield & Manchester Railway & Canal
LDM	Leeds, Dewsbury & Manchester
LNWR	London & North Western
LYR	Lancashire & Yorkshire
M&L	Manchester & Leeds
MidR	Midland Railway
Mid&NEJR	Midland & North Eastern Joint
NER	North Eastern
SYR	South Yorkshire

Aire & Calder Navigation

1. River Calder Wakefield–Castleford (Main Line)

Wakefield Warehouse	SE338203
River Calder Lock (Old Cut)	SE344199
LYR Bridge	SE346198
LYR (M&L) Bridge	SE353207
Broadreach Flood Lock	SE353211
Stanley Ferry aqueducts	SE356230
Birkwood Lock	SE359240
Kings Road Lock	SE374244
Woodnock Lock	SE392252
Mid R Bridge	SE 395252
Mid R Bridge (Stephensons)	SE400254
LYR Bridge	SE403256
Methley Bridge	SE409257

2. River Aire from Leeds–Castleford (Main Line)

Junction Leeds & Liverpool Canal	SE297331
Leeds Lock	SE309330
Knostrop Flood Lock	SE316319
Knostrop Falls Lock	SE322314
GNR Bridge (Site)	SE323313
Fishponds Lock	SE353300
Woodlesford Lock	SE367295
Lemonroyd Lock	SE385277
Kippax Lock	SE409279

3. Castleford–Goole

Castleford Flood Lock	SE428264
Bulholme Lock	SE443267
NER Bridge	SE 447268
NER Bridge, Fairburn	SE 469271
Mid&NEJR, Bridge, Brotherton	SE482255
Ferrybridge Flood Lock	SE485244
Bank Dole Junction	SE509239
NER Bridge	SE525233
Whitley Bridge	SE557228
Whitley Lock	SE567221
Great Heck Basin	SE584207
HBR Bridge (Site)	SE588208
NER Bridge	SE595205
Pollington Lock	SE615195
Southfield Reservoir	SE652187
NER Railway Bridge	SE731224

4. Goole Docks

Aldham Dock	SE746235
Barge Dock	SE 745230
Barge & Ocean Lock	SE748230
Ouse Dock	SE747233
Railway Dock	SE745234
Ship Dock	SE746233
South Dock	SE743228
Stanhope Dock	SE745236
Victoria & Ouse Locks	SE748234
West Dock	SE743234

5. Aire & Calder side cuts

Foxholes Lock	SE376246
Altofts Lock	SE389252
Fairies Hill Lock	SE396248
Fairburn Cut	SE478273
Castleford side lock	SE 428265

6. Aire Navigation & Selby Canal

Bank Dole Lock	SE512240
Beal Lock	SE536255
West Haddesley Flood Lock	SE571265
East Coast Main Line Bridge	SE577287
NER Railway Bridge (Site)	SE607298
NER Railway Bridge	SE613308
Lazy Cut (W–E)	SE623313–SE631318
Selby Lock	SE622323

7. Former Cuts and Channels
(a) Leeds–Knottingley

Thwaite Mill Lock	SE327313
Cryer Cut	SE353300–SE367294
Fleet Mill Lock	SE382284
Fleet Mill (Side Cut)	SE 279284
Methley Cut	SE385277–SE398279
Brotherton Cut Lock	SE494245

(b) Wakefield–Castleford

Lake Lock	SE356245
Kirkthorpe	SE360213
Penbank	SE383253

8. Old Aire Navigation

Haddesley Lock	SE581259
River Ouse Junction Airmyn	SE723263

9. Dewsbury Arm

Railway Bridge	SE251208
Railway Bridge	SE251198
Savile Town Basin	SE248209

Barnsley Canal

Heath Locks	SE349199
Agbrigg Locks (N–S)	SE351195–SE352192
LYR Bridge	SE350193
MidR Bridge	SE354184
Walton Locks (N–S)	SE355177–SE362167
Cold Hiendley Reservoir	SE365145
Winterset Reservoir	SE374146
MidR Bridge	SE368128
Royston Lift Bridge	SE370112
Dearne Aqueduct	SE355069
Barnsley Warehouse	SE349070
Barugh Locks (W–E)	SE316087–SE322088
Barnby Basin	SE3030821

Calder & Hebble (Main Line)

Sowerby–Brighouse

Sowerby Bridge Canal Basin	SE065236
LYR Viaduct, Copley	SE084227
Salterhebble Top Lock	SE095224
Hebble Brook Aqueduct	SE096223
Salterhebble Third Lock	SE096224
Longlees Lock	SE100218
LYR (M&L) bridge	SE100217
Woodside Mills Lock	SE101213
Elland Wharf	SE107214
Railway Bridge	SE108215
Elland Lock	SE111218
Park Nook Lock	SE114222

Cromwell Lock	SE129225
Brookfoot Lock	SE135228
Ganny Lock	SE139229
Brighouse Basin & Warehouse	SE148228
Brighouse Locks	SE149226

2. River Calder Reach–Brighouse–Anchor Pit

Anchor Pit Flood Lock	SE160218

3. Kirklees Cut

Kirklees Top Lock	SE168218
Kirklees Low Lock	SE172215

4. River Calder Reach–Kirklees–Coopers Bridge

LYR (M&L) Bridge	SE172213
Coopers Bridge Flood Lock	SE175206

5. Coopers Bridge Cut

Coopers Bridge Warehouse	SE176206
Coopers Bridge Lock	SE178205

6. River Calder Reach–Coopers Bridge–Battye Cut

LYR (M&L) Bridge	SE182207
Flood Gates	SE183208

7. Battye Cut

Battye Ford Lock	SE191203

8. River Calder Reach–Battye Ford–Ledgard Bridge

Ledgard Flood Lock	SE202197

9. Mirfield (Shepley Bridge) Cut

Shepley Bridge Lock	SE216197

10. River Calder Reach–Shepley Bridge–Greenwood

Greenwood Flood Gates	SE217198

11. Greenwood Cut

Greenwood Lock	SE223197

12. River Calder Reach–Greenwood–Dewsbury

Calder Warehouse	SE230203
LYR Bridge	SE232204
Raven's Wharf	SE233205
LNWR (LDM) Bridge	SE234205

13. Thornhill (Long), Horbury & Broad Cuts

LNWR (LDM) Bridge	SE233203
LYR (M&L) Bridge	SE235201
Thornhill Double Locks	SE250198
Alders or Mill Bank Lock	SE258194
Figure of Three Locks (2)	SE267188
Horbury Bridge	SE280179
Broad Cut Top Lock	SE302171
LYR Bridge	SE304172
Broad Cut Bottom Lock	SE309173

14. Calder Reach–Broad Cut–Thornes

Thorne's Flood Lock	SE319187

15. Thornes Cut

Thornes Locks	SE326189

16. Calder Reach–Thornes–Wakefield

GC & GN JR Bridge	SE335193
Warehouses	SE337198
Wakefield Flood Lock	SE337197

17. Fall Ings Cut

Fall Ings Locks	SE344198

Branches and Old Sections of Canal
18. Salterhebble (Brooksmouth) Branch

Boat Dock	SE097227

19. Halifax Branch

Locks (N–S)	SE097236–SE098228
Aqueduct (Hebble Brook)	SE098234

Siddal Engine House	SE098235
Halifax Basin	SE098248

20. Old Cuts

Salterhebble Old Locks	SE095223
Elland Old Lock	SE107214
Tag Cut (W–E)	SE125219–SE129222
Ledgard Bridge Old Lock	SE203195
Dewsbury (Ravensthorpe) (N–S)	SE240209–SE237205
Cut End–Savile Town Basin (N–S)	SE247213–SE248209
Figure of Three Old Cut (W–E)	SE264195–SE26191
Healey (New) for M&L	SE270189
Horbury side Cut	SE279181
Horbury Old Cut (W–E)	SE279182–SE281179
Wyke Old Lock on Calder near Horbury	SE297175
Old Broad Cut	SE302172–SE308173

Huddersfield Broad Canal

Colne feeder (site)	SE148163
Apsley Goit (N–S)	SE 149164–SE150162
Apsley Basin	SE149165
Turnbridge (Locomotive Lift Bridge)	SE149167
Red Doles (Fairtown Green) Lock (9)	SE153184
Falls Lock (8)	SE156185
Fieldhouse Green (7)	SE157186
Reading Lock (6)	SE159188
Turnpike Road Lock (5)	SE163189
Longlands Lock (4)	SE170193
Ladgrave Lock (3)	SE172197
Mid R Bridge	SE173198
Colne Bridge Lock (2)	SE178202
LNWR (HMRC) Bridge	SE178203
Coopers Bridge Lock (1)	SE177204

Dearne & Dove Canal

Main Canal (Barnsley–Swinton)

Stop Lock, (Lock 19), Barnsley	SE 356068
Stairfoot (8) Locks	SE377047–SE387043
Brampton (4) locks	SE412023–SE415022
GC (SYR) Lift bridge	SE414022
Dove Aqueduct	SE414022
Swinton (6) Locks	SK461995–SK462989

Worsborough Branch

Worsborough Basin	SE353034
Worsborough Reservoir	SE348034

Elsecar Branch

Elsecar Locks (6) (W–E)	SE389003–SE401013
Elsecar Basin	SE388002
Elsecar Reservoir	SK383995

Private Canal

Fearnley Cut (Private) (N–S)	SE237208–SE236205
Lake Lock–Bottom Boat (W–E)	SE356245–SE365246

RAY SHILL

NORTH WEST CANALS
Manchester, Irwell & the Peaks
THROUGH TIME

The No. 1 Best Selling Colour
OVER
400,000
COPIES
SOLD
Local History Series

North West Canals
Through Time
Ray Shill

This fascinating selection of photographs traces some of the many
ways in which North West canals have changed and developed over
the last century.

978 1 4456 1894 4
96 pages, full colour

RAY SHILL

EAST MIDLAND CANALS

Soar, Trent, Derby, Leicester & Nottingham

THROUGH TIME

East Midland Canals
Through Time
Ray Shill

This fascinating selection of photographs traces some of the many
ways in which East Midland canals have changed and developed
over the last century.

978 1 4456 1149 5
96 pages, full colour

Available from all good bookshops or order direct
from our website www.amberleybooks.com

RAY SHILL

WEST MIDLAND CANALS
Severn, Avon & Birmingham
THROUGH TIME